A DESERT ILLUMINATED

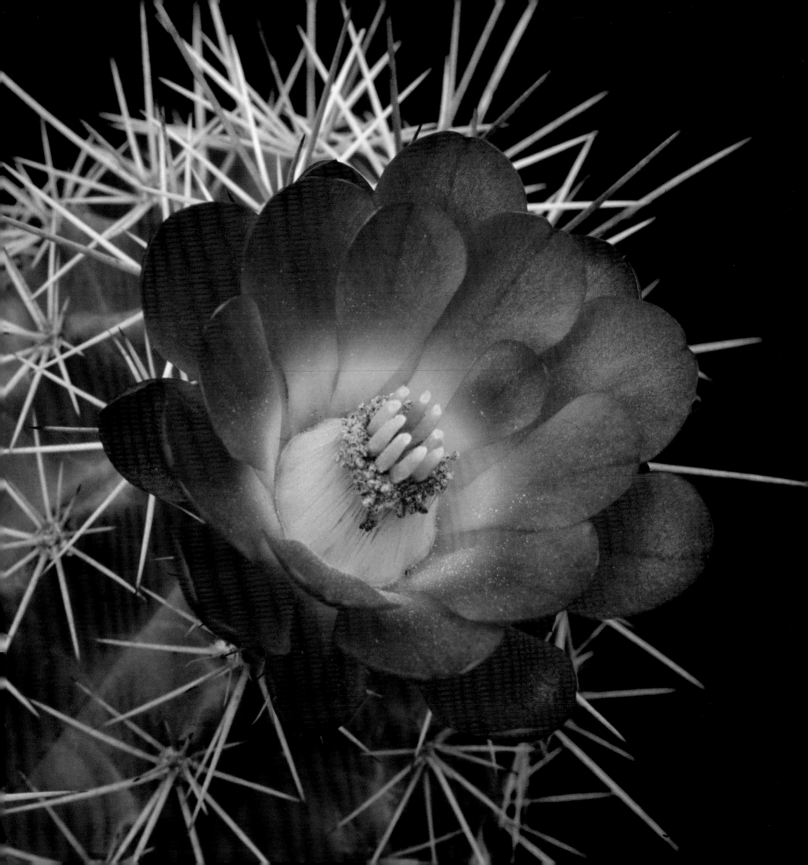

A DESERT
Illuminated

Cactus Flowers of the Sonoran Desert

PHOTOGRAPHS BY

JOHN P. SCHAEFER

ESSAYS BY

JOHN ALCOCK

MARK A. DIMMITT

JOHN JANOVY, JR.

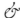

DAVID YETMAN

THE ARIZONA-SONORA DESERT MUSEUM PRESS

The most beautiful experience we can have is the mysterious—the fundamental emotion which stands at the cradle of true art and true science.

~ ALBERT EINSTEIN

*For my wife Helen for her support and seemingly infinite patience with
my photographic pursuits.*

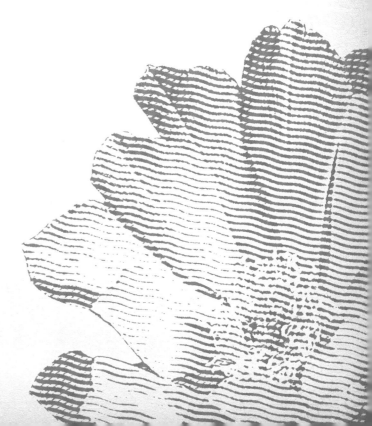

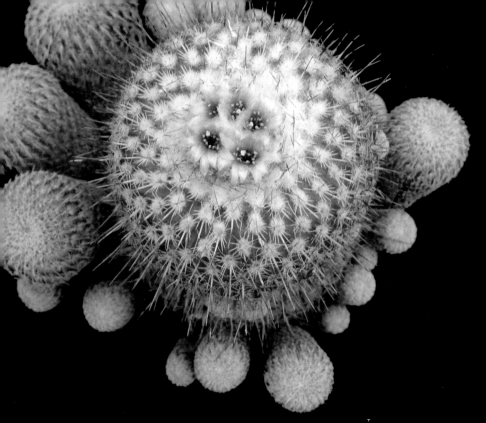

First Edition
Published in the United States of America by Arizona-Sonora
Desert Museum Press
2021 N. Kinney Road │ Tucson, Arizona 85743
520-883-3028 │ asdmpress@desertmuseum.org
www.desertmuseum.org

ISBN 978-1-886679-01-6
Copyright registered with the U.S. Library of Congress

Book development by Richard C. Brusca
Design by Terry Moody at Studio Orange Street
Printed in Canada by Friesens

CONTENTS

CACTUS DESCRIPTIONS
BY MARK A. DIMMITT

PHOTOGRAPHING THE SONORAN DESERT

A memorable photograph evokes the difference between "looking" and "seeing"—actions we often equate. In reality, they are vastly different. At a casual glance, the Sonoran Desert appears to be a landscape in monochrome. The expected vibrant greens of plants native to more fertile and wet climates are replaced with less conspicuous shades of sage or gray. In fact, most of the plants in this region discarded the luxury of leaves (at least, large leaves) long ago to conserve that most precious of resources, *water*. A thick, waxy skin resisting the evaporation of water and capable of photosynthesis is a far better alternative for a desert plant. And for most of the cycle of a year, for both plants and animals, being inconspicuous in the Sonoran Desert is propitious—an aid to survival.

This dull palette changes dramatically with the coming of spring and summer. The biological imperative of every living thing to create a new generation leads to dramatic changes in behavior and displays. A cactus encircled with unforgiving spines suddenly sprouts buds that open into richly hued flowers, spanning the colors of the rainbow and stretching across the desert. For a brief time, the plant's glorious message to the outer world shifts from "beware" to "come hither."

The beauty of these plants and their flowers is an irresistible attraction luring me to return with my camera year after year. To isolate the plant and flowers from a typically chaotic background of rocks and competing plants, I often place a sheet of black construction paper behind the cactus. Most of the photographs in this book were made on color transparency film using a single-lens, medium-format camera fitted with a macro lens. The color transparencies were scanned to create digital files, from which the reproductions and prints were made.

Take time to look closely at this remarkable world. With patience, you will begin to see and appreciate its marvelous wonders.

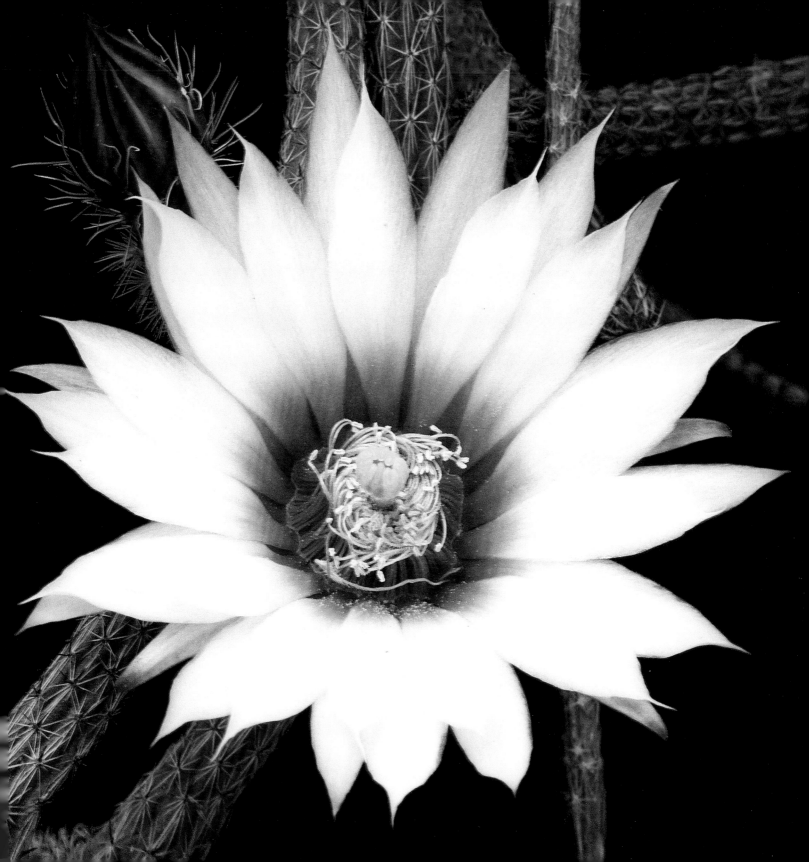

CACTI: A BRIEF NATURAL AND HUMAN HISTORY

We in the arid lands of the Americas seldom have difficulty identifying plants as cacti: they have spines, are leafless (except for a few primitive genera), and are usually green underneath their protective spines and hairs. Africa has a number of plants that also have spines and green branches, but after rains these will leaf out, thus betraying their non-cactushood.

Cacti are native to the Americas. Millions of cactus plants now grow elsewhere in the world, but all are transplants from American parents except for one African species, the arboreal *Rhipsalis baccifera*, probably carried there by birds.

Cactologists widely agree that cacti evolved from the Portulacaceae (the purslane family), or a close relative, probably in northwestern South America or somewhat farther south in the central Andean region. The family Cactaceae appears to have evolved 35 to 75 million years ago and reached North America, which was then separated from South America, by "island-hopping" across the Caribbean. From their humble beginnings, cacti have become spectacularly successful; Cactaceae species number around 1,800 (depending on the authority one wishes to cite). More than 900 species occur in Mexico alone.

For people unfamiliar with these succulents, cacti are decidedly strange. Members of the Cactaceae range from the barely noticeable Andean genus *Blossfeldia*, with mature individuals weighing less than an ounce or so, to shrubby plants several meters high that can grow in large forest-like stands covering several acres (*Stenocereus gummosus*). Some cactus species grow as vines that curl like snakes through trees and on rooftops (for example, the genera *Pereskiopsis* and *Hylocereus*), whereas other species form epiphytic masses with roots that never touch the ground (*Rhipsalis* and *Selenicereus*), and some species are huge trees exceeding 60 feet in height and

weighing many tons (*Carnegiea*, *Neobuxbaumia*, and *Pachycereus*).

Despite the great variety in growth forms, a specific combination of characteristics distinguishes members of the Cactaceae. First of all, as adults cacti employ the crassulacean acid metabolism (CAM) pathway of photosynthesis (as do several other plant families). CAM plants wait till night, when other plants are shut down, to open their surface pores (stomata) and take in carbon dioxide, and then they wait for sunlight before undertaking the complex biochemical processes that enable them to survive and grow. This allows CAM plants to hoard precious water, trapping it inside during the hottest hours—quite a remarkable accomplishment. Without CAM, cacti could never have adapted with such marvelous success to hot, arid habitats and evolved their wide assortment of shapes and sizes.

And, of course, cacti have unmistakable modified leaves, better known as spines, that emerge from special structures called areoles, the wartlike lateral buds. Most areoles have a cluster of spines, ranging from one to many. Often resembling tiny pincushions, areoles may be raised like a miniature knob, or they may be flat or even slightly concave. Their number, shape, size, color, spacing, and the size, shape, and contour of the ribs on which they grow—as well as the number, length, shape, thickness, and arrangement of the hairs and spines that grow from them—can be as diagnostic of the various species as fingerprints are diagnostic of individual humans.

The presence of areoles with spines clearly distinguishes cacti from all other plant families. In addition to their obvious value in deterring potential herbivores (and collectors!), spines serve critically important functions—cutting back on water loss and eliminating leaf wilt (typical of so many other plants), thus protecting the plants from damage due to high temperatures or extreme

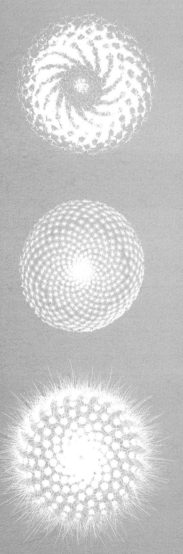

drought. Spines occur in marvelous variety—tapered to a sharp point (subulate), bristle-like (setose), needlelike, conical, cylindrical, planed, straight, curved, twisted, hooked, and feathered—to name the most common. They may point outward, upward, sideways, or downward. Spines range in length from 1 millimeter to more than 30 centimeters (12 inches) and come in a range of opaque to translucent colors, including maroon, purple, red, orange, black, and white. They may be nearly as thick at the base as ice picks, and as rigid and long. Prickly pears and chollas grow barely visible spines called glochids. These tiny, hairlike spines are covered with reverse barbs and perhaps even a toxin. They break off easily and tend to remain embedded in the flesh, causing considerable discomfort, a reminder not to mess with the plant.

In some cases, the thick growth of spines and areolar hairs at and near the growth tips of the plant (apical meristem) provides protection for a cactus against freezing or sunburning. The numerous spines at the growth tips of saguaros allow these frost-sensitive plants to thrive well into the zone where hard winter freezes occur. The same spines can also, in some species, act to shade the plant from intense sunlight. In climates where fog or heavy dew are common (as in some coastal deserts), spines direct water to the plant and downward to the roots. Spines are often indirectly involved in propagation by attaching broken-off sections of the plant to passersby, thus obtaining a free ride to a new location. The longest spines tend to grow on high-elevation columnar cacti in the Andes, where they serve multiple functions as insulators from cold and ultraviolet rays, dew collectors, and defenders of the plant.

For all their spiny unfriendliness, cacti produce lavish floral displays, with some blooms reaching more than 7 inches in diameter. As John Schaefer's photographs demonstrate, cactus flowers are unequalled in richness and vibrancy of color; they go all out to attract pollinators. Many species produce a thicket of stamens in a hue contrasting with the petals, enhancing the beauty of the flower. In some species, all or nearly all flowers in a particular region open simultaneously—not across the

span of a few days, but the same day, or night, at virtually the same time. In other species, flowering is staggered over several weeks to more than a month. A few species bloom intermittently throughout the year, some opportunistically (whenever they feel like it!), others in regular flowering seasons. One night, in my front yard a single apple cactus (a subspecies of *Cereus hildmannianus*) exhibited more than 40 flowers opening at one time, all with a diameter of 20 centimeters (8 inches). By mid-morning the following day all had closed and drooped. Most cactus flowers endure less than 24 hours, much to the disappointment of flower watchers. But the early closing helps the plants minimize water loss.

For the most part, white flowers open at night and are pollinated by moths and nectar-feeding bats, whereas colored flowers open during the day and are pollinated by hummingbirds and insects, hummingbirds preferring the red tubular forms. Flowers with sweet scents attract moths and other insects, while those with less pleasant scents (to us) tend to attract bats.

Bat pollination affords a notable advantage in that bats are far ranging and the broad dispersal of pollen can be some assurance against incestuous pollenization and hybridization (plants have incest taboos, too!).

Bat pollination affords a notable advantage in that bats are far ranging and the broad dispersal of pollen can be some assurance against incestuous pollenization and hybridization (plants have incest taboos, too!). The lesser long-nosed (*Leptonycteris yerbabuenae*) and other nectarivorous bats are superb pollinators. If you are lucky enough to see them in action (using night vision devices), or see photos of them at work, you will notice their dark heads covered with golden pollen. Since they are greedy sippers of nectar, to attract them the cactus must produce

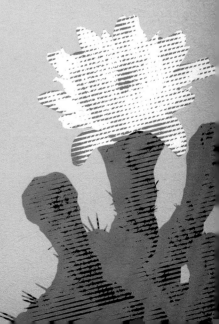

copious amounts of the sugary fluid, which is metabolically expensive for the plants, but worth the effort.

All cacti produce edible fruits. Some are grainy, dry, and tasteless, some bland. A few are decidedly sour, but most species produce fruits that yield a sweet, tasty pulp that may be white, green, yellow, red, purple, or sienna. Most fruits have husks that are bristly, scaly, spiny, woolly, or thick. These leathery covers demonstrate the plants' evolutionary strategies for protecting their seeds. The fruits of many species split open when they are ripe, exposing the sweet pulp, often colorful and attractive to birds and bats—and humans. In other cases the hair, scales, spines, wool, and husk soften and slough off. The pulp itself ripens and changes color as the small to tiny seeds mature, meaning that fruit eaters gorging themselves on the succulent pulp will also ingest and partially digest the seeds. Digestion in free-moving animals like birds, insects, and mammals not only aids dispersal of the seeds, but also appears to help soften or dissolve the seed coat, promoting germination in some species. The scat in which the seeds are defecated may also serve as a fertilizing medium. Thus, by eating the fruits creatures are doing cactus a favor even as it bestows a favor upon them.

Native peoples who live around cacti have found many ways to use them. The fruits have long provided them with an important source of food and medicine. Usually tasty, the fruit pulp is rich in vitamins, and the seeds are a splendid source of protein and oils. In central Mexico and in Peru native peoples domesticated prickly pears (*Opuntia* sp.) centuries ago, both for the fruits and for the larvae of scale insects (*Dactylopious* spp.) that infest the pads—from which the people manufactured the reddish dye called cochineal. The pads (anatomically they are branches!) of some Opuntias are also edible (and sold today in some markets). The mucilage found just under the tough outer bark has medicinal properties and can also be used for making shampoo, plaster, and glue. Some columnar cacti, such as *Pachycereus pecten-aboriginum* of Mexico and *Trichocereus atacamensis* of the southern Andes, yield high-quality lumber for floors, furniture, doors, and roof beams. The long spines of

certain species function well as sewing needles, which permitted pre-Incan natives of coastal Peru and Chile to weave some of the finest textiles the world has ever known. Brazilians of the Northeast Region look to the flowering of the giant *mandacarú* (*Cereus jamacaru*) to predict the arrival of rains after the lengthy summer drought of the arid *sertão* region. Practical applications for human society and the ecosystem abound, but cactus offer more than services. They also offer inspiration.

Cactus flowers, illuminating usually somber desert landscapes with hundreds of varieties, seem irresistible to the human eye. Their petals of brilliant technicolor or shimmering pastels invite your close inspection. For those unable to visit the regions where cacti send out their blossoms, the images in this book offer an exceptional display of the variety and elegance of cactus flowers. Even for those who frequent well-spined landscapes, these superb larger-than-life photographs help us focus on, and marvel at, the deep consonance of function and art in the family Cactaceae.

DAVID YETMAN is Research Social Scientist at the Southwest Center of the University of Arizona (Tucson). He is author of numerous books and articles on the people and plants of the southern Sonoran Desert Region, including *The Great Cacti. Ethnobotany and Biogeography of Columnar Cacti*. Yetman is also host of the nationally syndicated PBS television series *The Desert Speaks* (co-produced by the Arizona-Sonora Desert Museum).

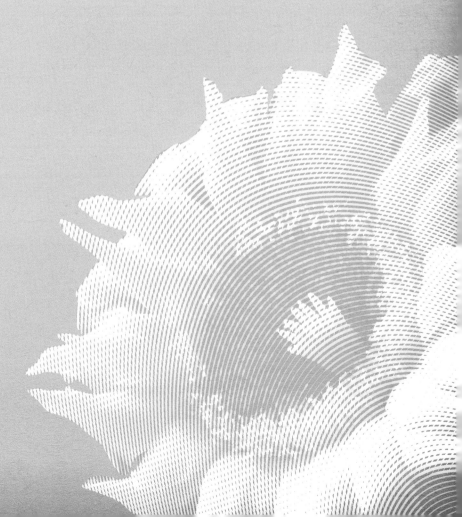

WHAT MAKES A PLANT A CACTUS?

MARK A. DIMMITT

Cacti comprise a small family with a big reputation. About 2000 species have been described, all but one from the New World, where the family originated. Although they are most common in arid and semiarid habitats, many species have adapted to the wet tropics of Mexico and Central and South America. The Sonoran Desert Region supports 277 taxa (species, varieties, and hybrids) by our current accounting—less than 5% of the total plant diversity of this area. However, their diversity is disproportionate to their abundance. They tend to visually dominate landscapes because of their striking sculptural forms and often large, showy flowers. These traits also make cacti horticulturally important. Whether planted in landscapes or kept in pots on benches or windowsills, there are legions of avid cactus collectors all over the world.

Many plants are mistakenly called cacti. Agaves (century plants) are not cacti. Ocotillo is not a cactus. Succulent euphorbias are not cacti. A cactus is any plant in the botanical family Cactaceae. Cactus plants are fairly easy to recognize if one knows what to look for. But the spiny stems of some Old World euphorbias fool even knowledgeable botanists. It's the flowers that are unmistakable, and here a suite of traits is seen that distinguishes cacti from all other plants. One unique character is the many petals that intergrade with many sepals. In botany "many" means more than 10; most cactus flowers have scores of "tepals" (the collective term for sepals and petals). All other flowering plants have distinct sepals and petals (or sometimes none); there are no intermediate parts. Cacti also have many stamens, usually hundreds. And the stigma has several to many lobes; they may be curled together like the fingers of a fist or spread out to resemble a many-armed starfish. There are other diagnostic traits of the cactus family, but these are sufficient for identification. They

are readily visible in most of the images in this book.

Cacti are arguably unique in bearing areoles. Areoles are the felty cushions on the stems from which spines, branches, and flowers grow. Areoles are defined as occurring only in cacti. But many African succulent euphorbias have structures that look just like areoles, although they are not felty—another aspect of convergent evolution between these two families. You should rely on the flowers to tell you what you're looking at. If it isn't in flower, you often can't be certain.

There are three subfamilies of cacti. The opuntioids (chollas and prickly pears) are a distinct and easily recognizable group. All of our other regionally native cacti belong to the cactoid subfamily. The third subfamily (the pereskioids) occurs in the South American tropics. All of the native cacti in the Sonoran Desert Region are succulents (the pereskioids are woody trees and shrubs, not succulents).

MARK A. DIMMITT was Curator of Botany at the Arizona-Sonora Desert Museum for 18 years and became Director of Natural History in 1997. Besides studying desert plants scientifically, he has been growing them as a hobby for more than 40 years. He is a widely recognized Sonoran Desert ecologist, a specialist on cacti and other succulents, and a horticulturalist who has achieved fame through his unique cultivars of cacti and Old World *Adenium* (a genus in the dogbane family Apocynaceae).

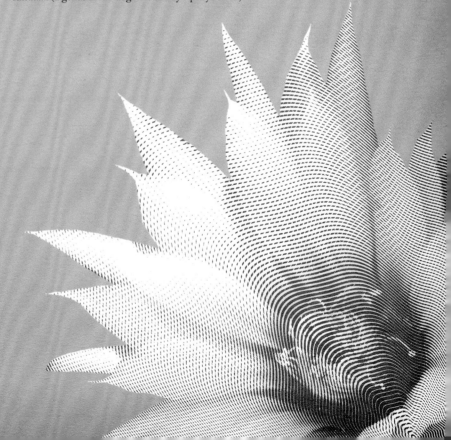

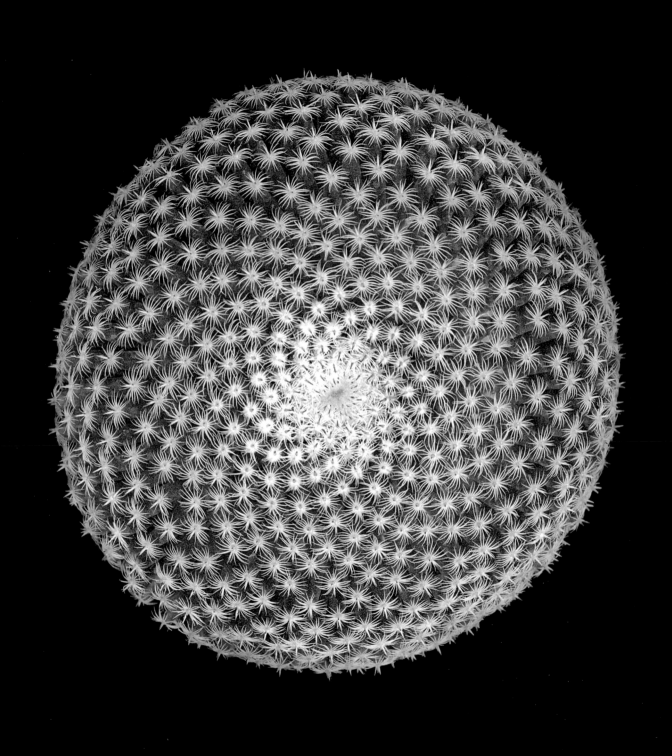

PINCUSHIONS AND OTHER DIMINUTIVE CACTI

MARK A. DIMMITT

The term pincushion refers mainly to the many species of *Mammillaria*, with about 54 taxa in our region. There are several other smaller genera, including *Coryphantha*, *Echinomastus*, and *Sclerocactus* that resemble pincushions to the uninitiated. Individual stems in our species range from less than an inch tall and wide, to about 6 inches thick and a foot long. Some species have mostly single stems, while others form huge colonies of hundreds of heads. Each spiny areole is borne at the tip of a tubercle, for which reason mammillarias are also called nipple cacti. (*Mammillaria* means "little teat.") The flowers are often quite large in relation to the size of the plant. In some species they are borne in large numbers and create an eye-catching display. The fruits of some species are brightly colored and may be as showy as the flowers.

Most plants exhibit a spiral arrangement of leaves, flowers, and seeds, but it can be difficult to discern. The short spines of this pincushion cactus reveal a clear view of the spiraled tubercles. The numbers of clockwise and counterclockwise spirals are almost always adjacent numbers in the Fibonacci series, in which each number is the sum of the two preceding ones (1, 1, 2, 3, 5, 8, 13, 21, 34, etc.). The underlying explanation for this phenomenon is complex and involves mystical-sounding terms such as the Golden Ratio. The short answer is that this is the most efficient way to pack similar units together, minimizing the plants' energy required to produce them. It is also the most efficient arrangement of leaves for capturing sunlight, of flower petals for attracting pollinators, and of seeds or fruits for displaying their availability to hungry animals.

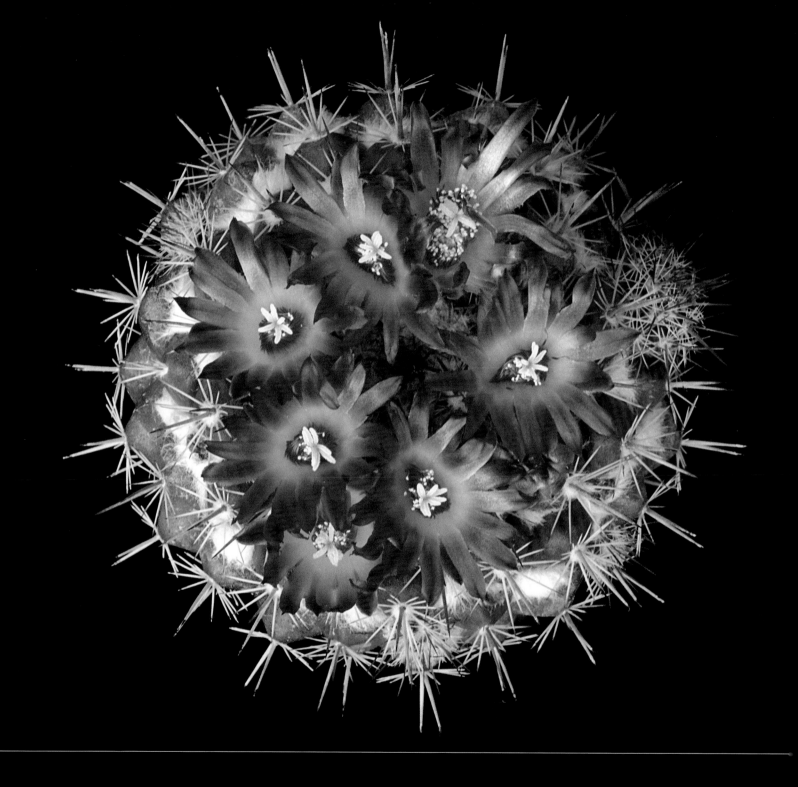

PINCUSHION CACTUS *Mammillaria standleyi* PITAHAYITA

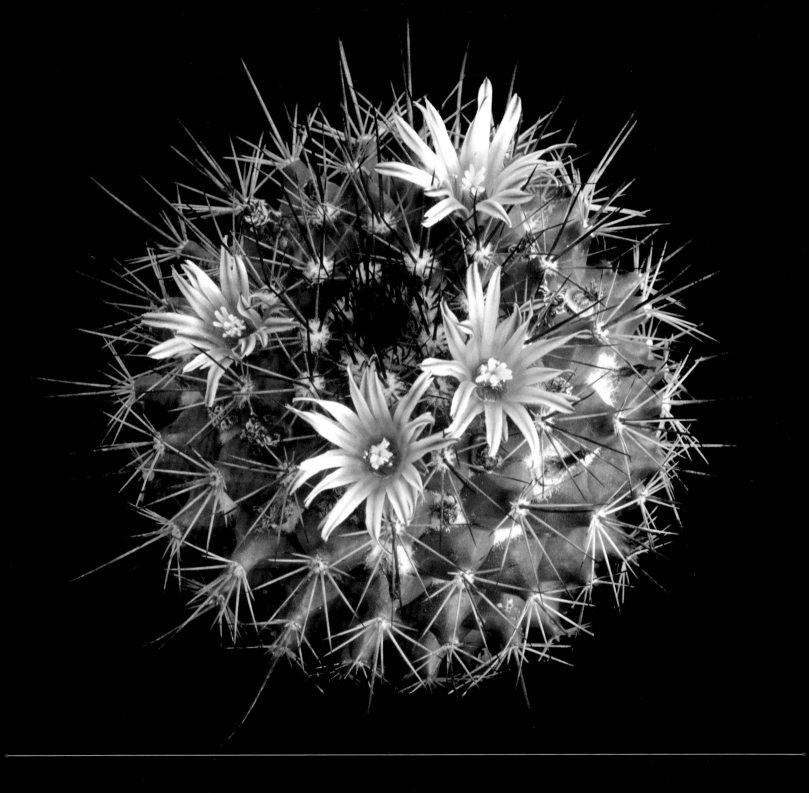

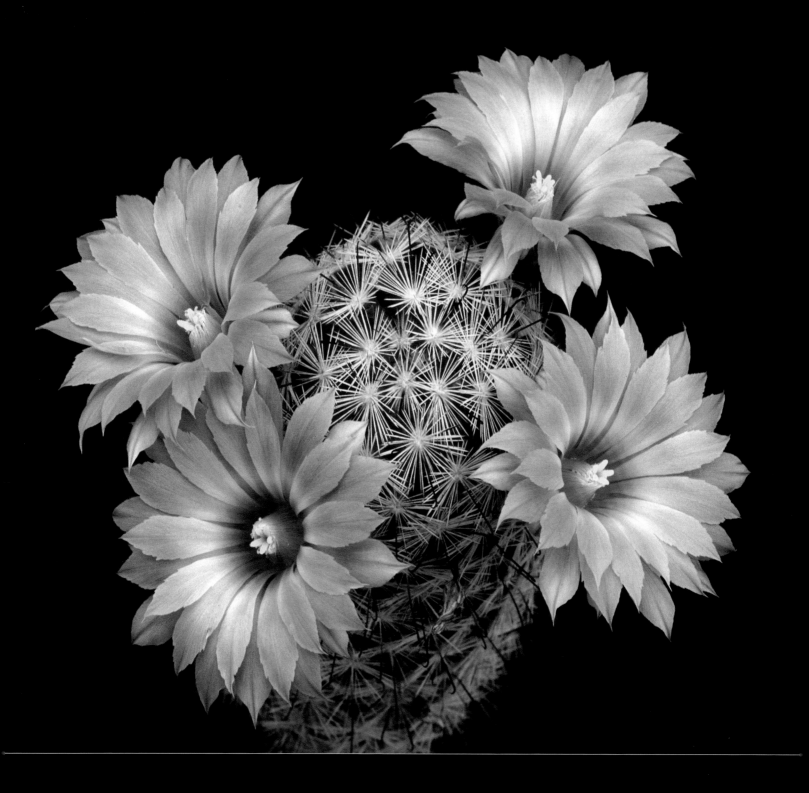

CORKSEED PINCUSHION *Mammillaria tetrancistra* VIEJITA

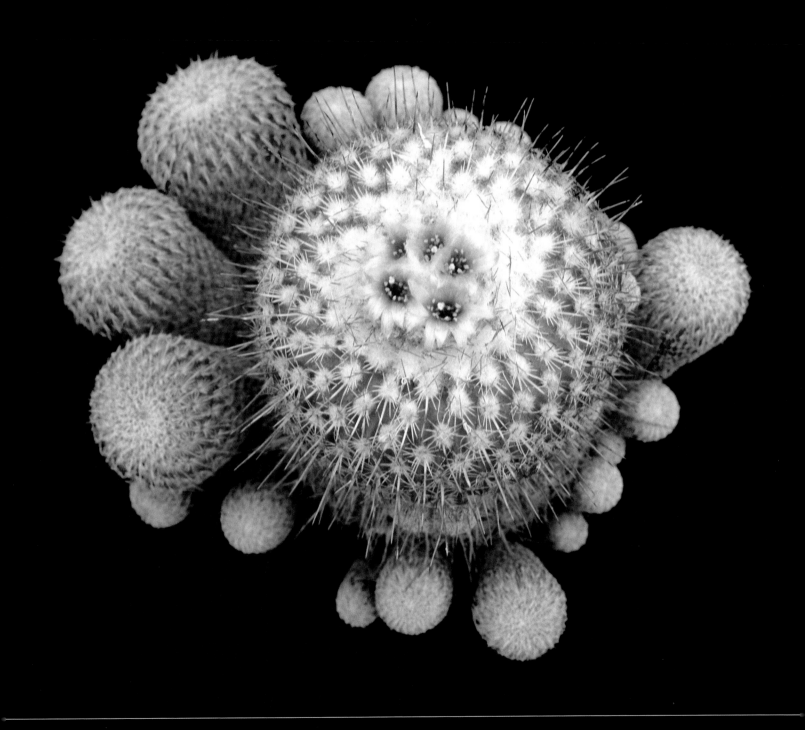

BUTTON CACTUS *Epithelantha micromeris* 23

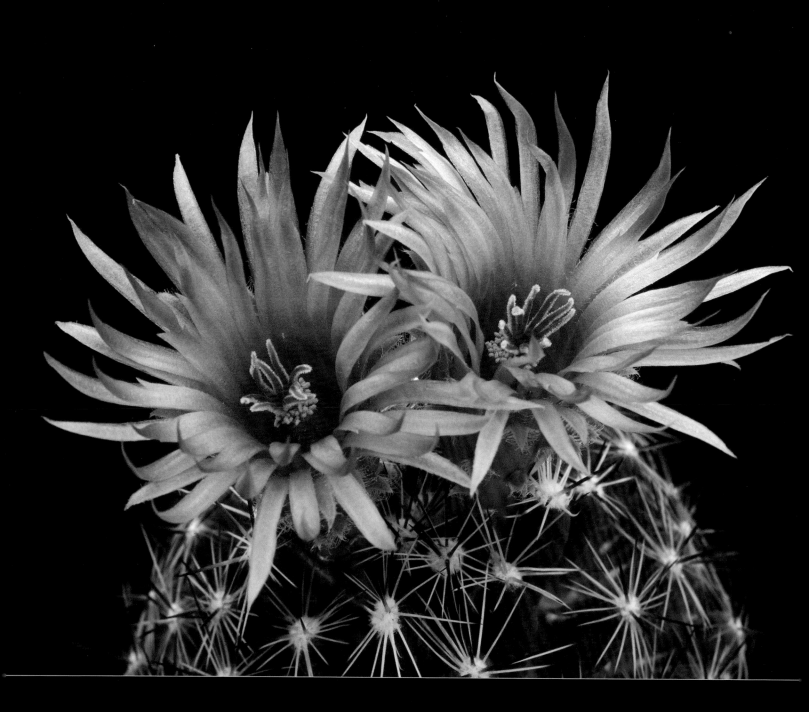

24 BEEHIVE CACTUS *Coryphantha vivipara*

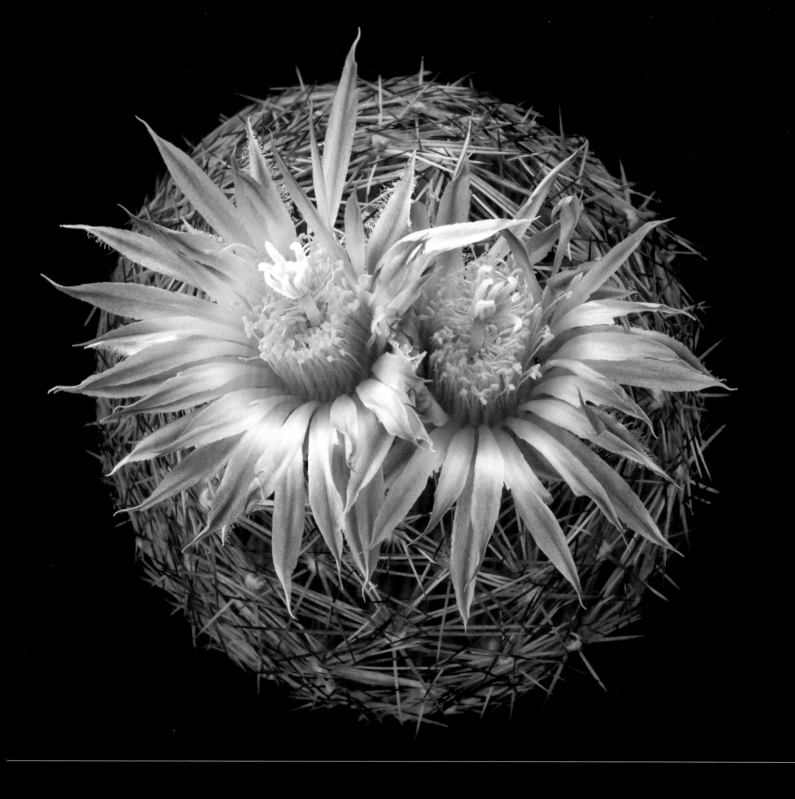

BISBEE BEEHIVE CACTUS *Coryphantha vivipara* var. *bisbeeana* 25

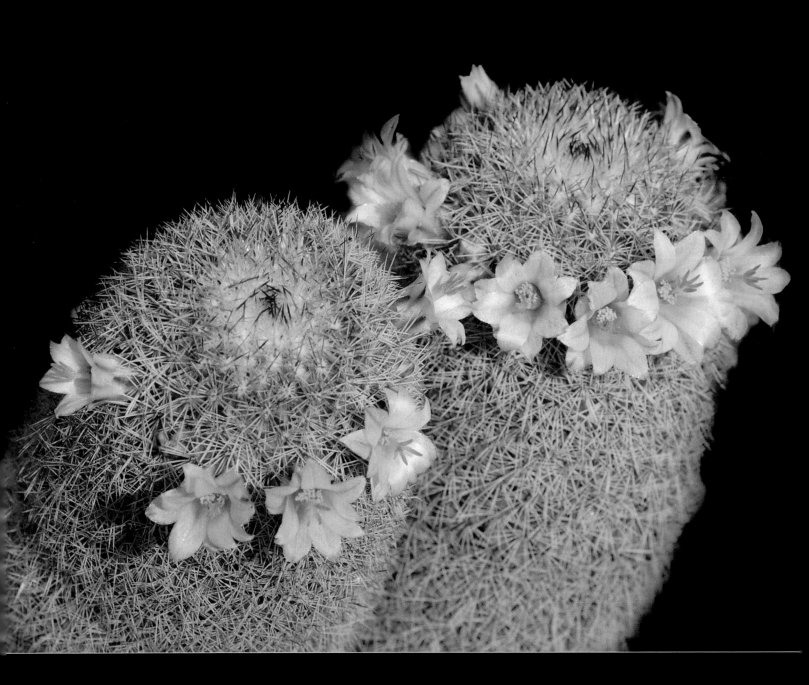

PINCUSHION CACTUS *Mammillaria estebanensis*

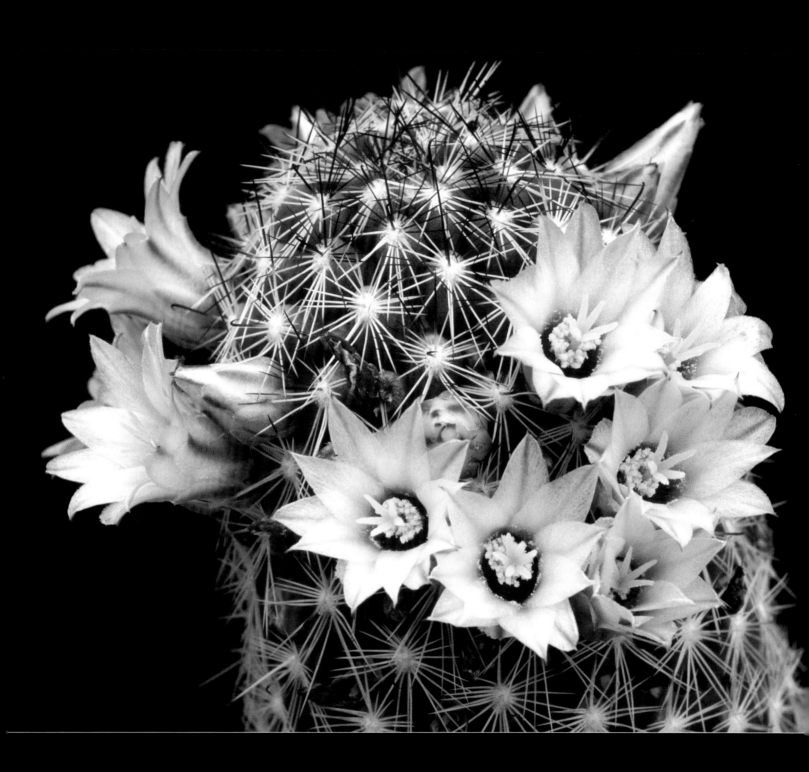

PINCUSHION CACTUS *Mammillaria phitauiana* PITAHAYITA 27

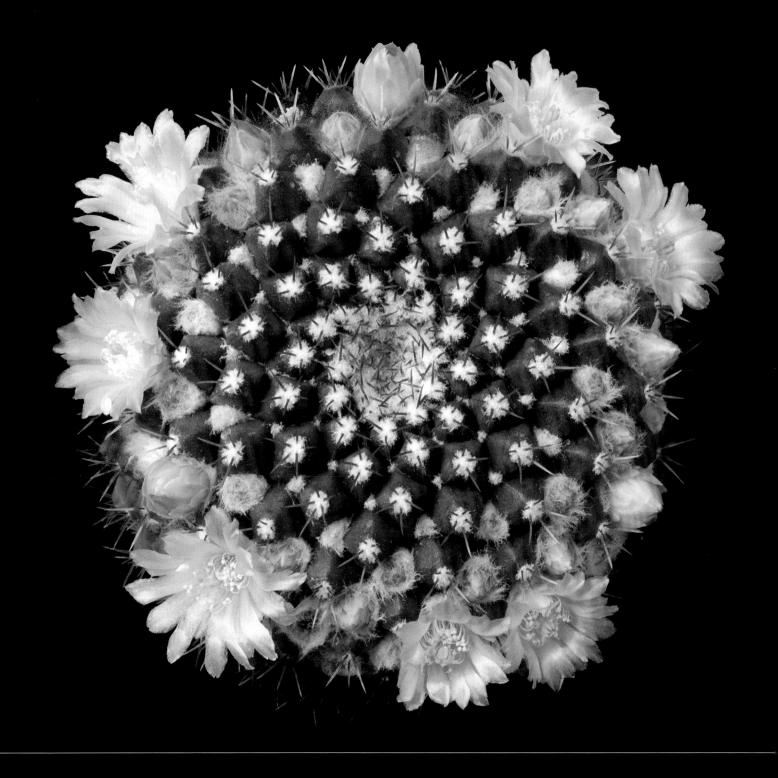

PINCUSHION CACTUS *Mammillaria marksiana*

PINCUSHION CACTUS *Mammillaria senilis* 29

Cochemiea poselgeri BIZNAGUITA

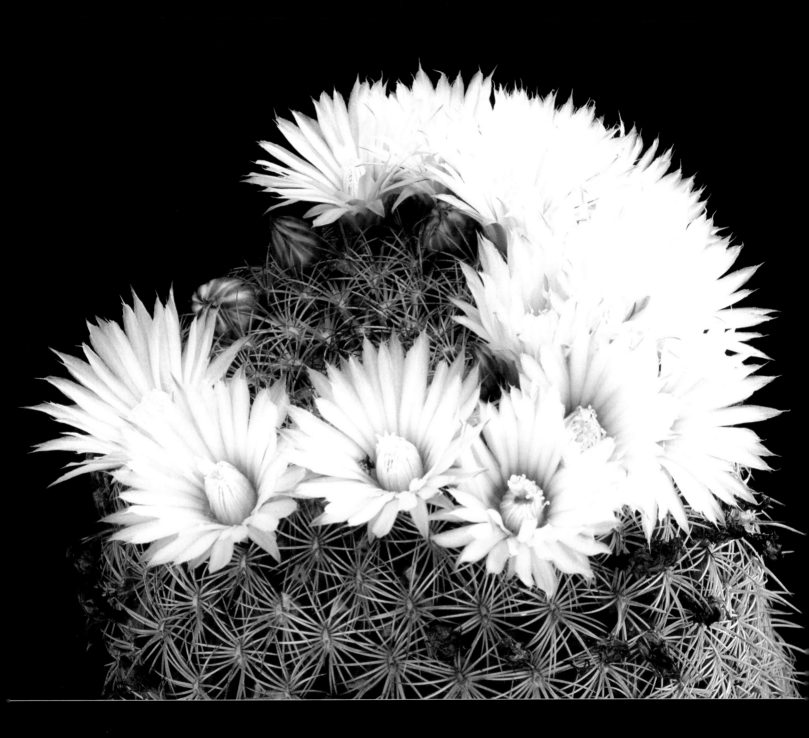

GOLDEN BEEHIVE CACTUS *Coryphantha recurvata* 31

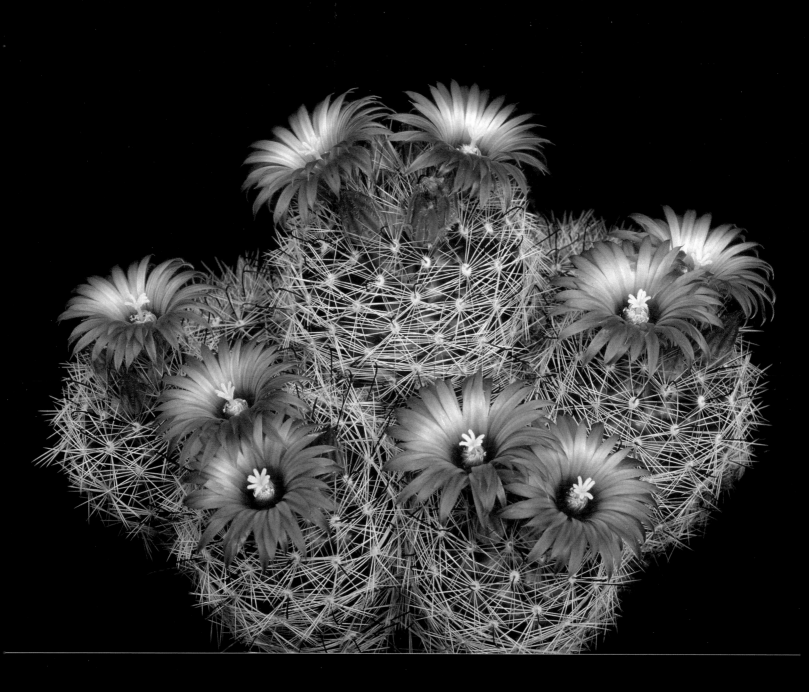

WRIGHT PINCUSHION *Mammillaria wrightii*

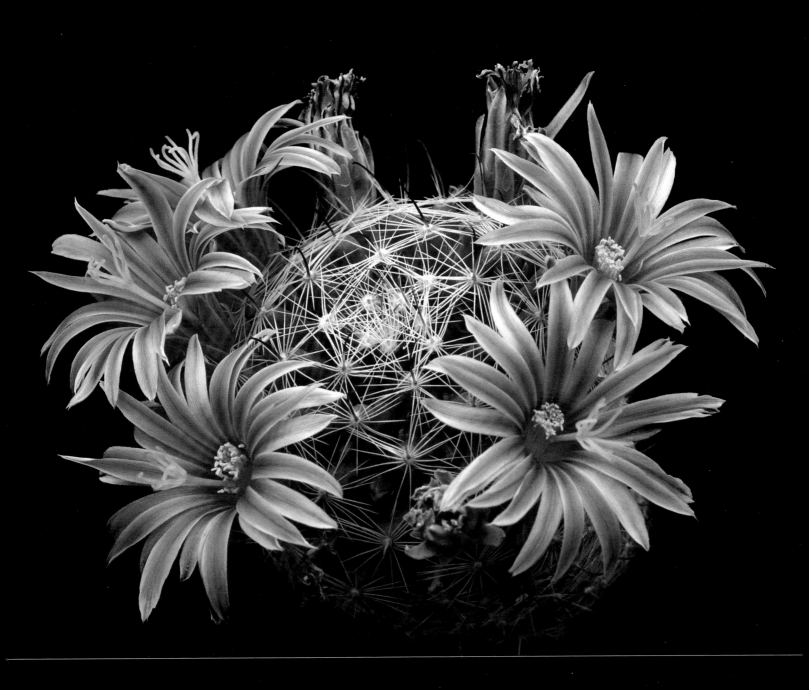

PINCUSHION CACTUS *Mammillaria boolii* 33

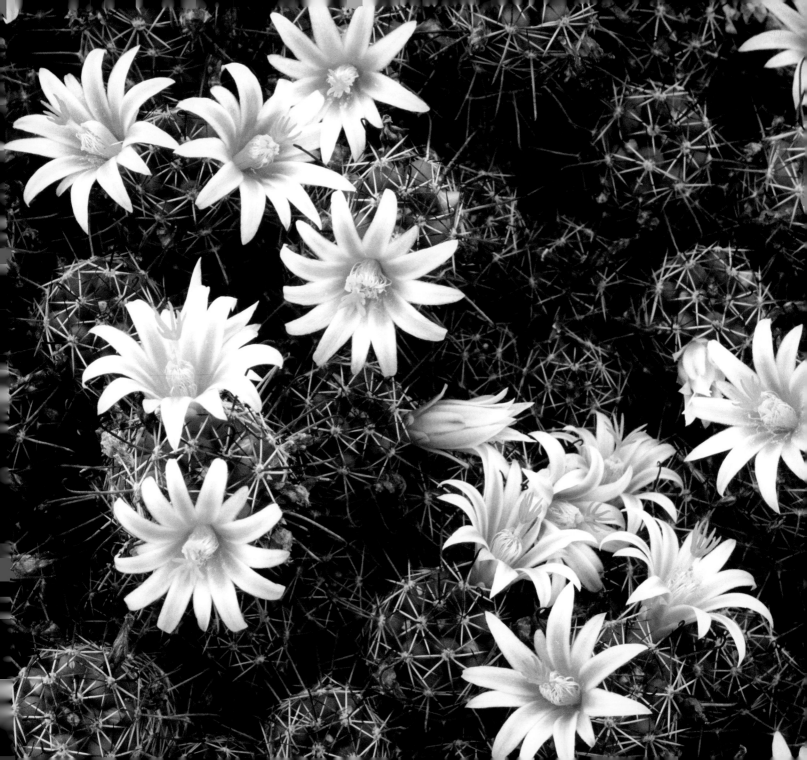

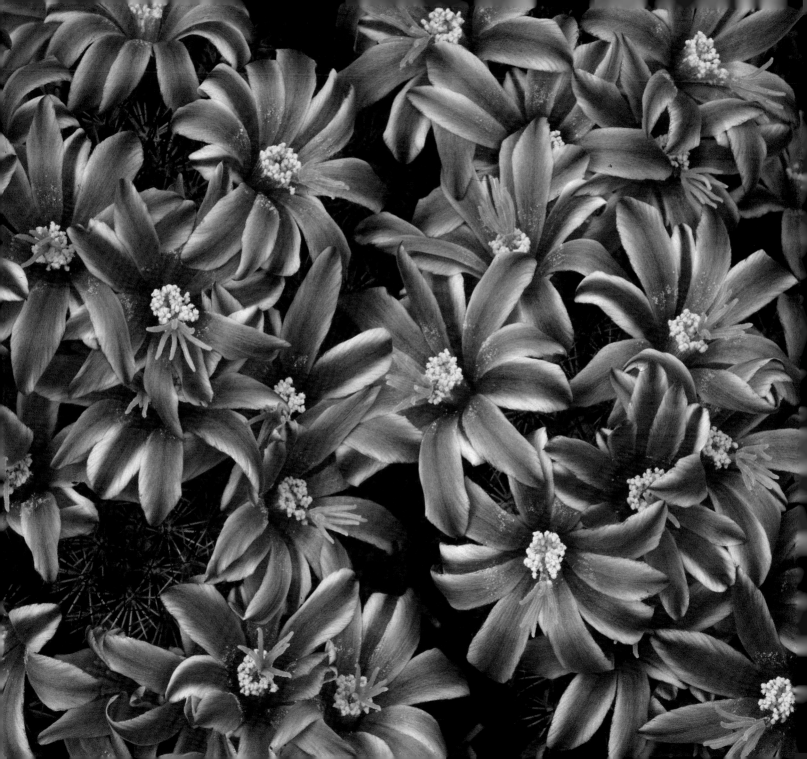

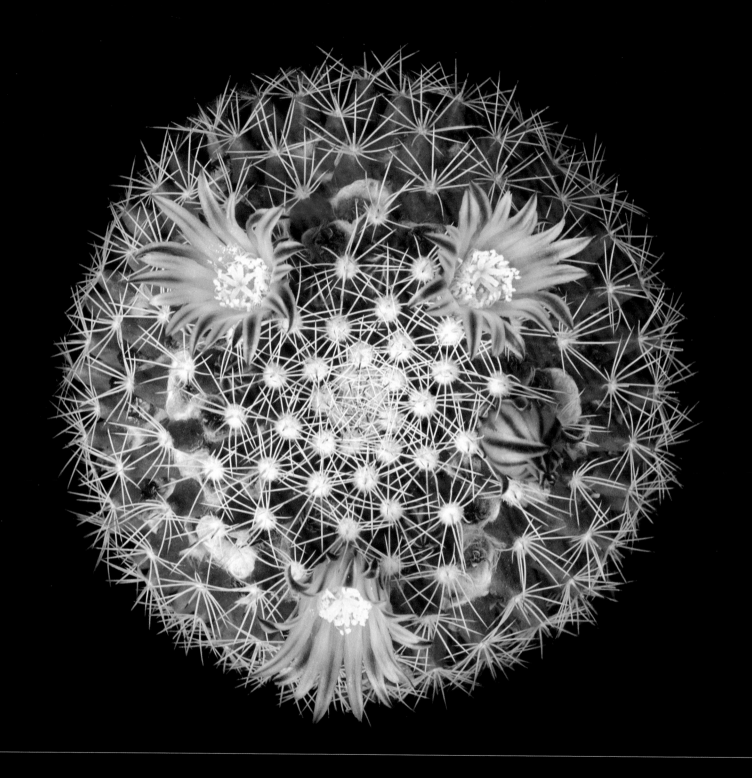

PINCUSHION CACTUS *Mammillaria petrophila* PITAHAYITA

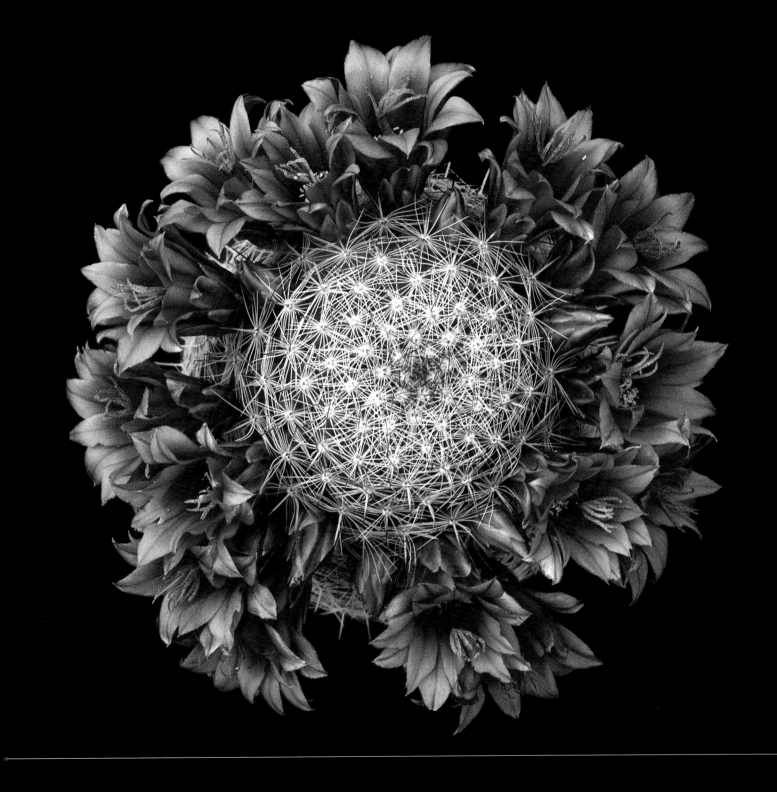

PINCUSHION CACTUS *Mammillaria grahamii* 37

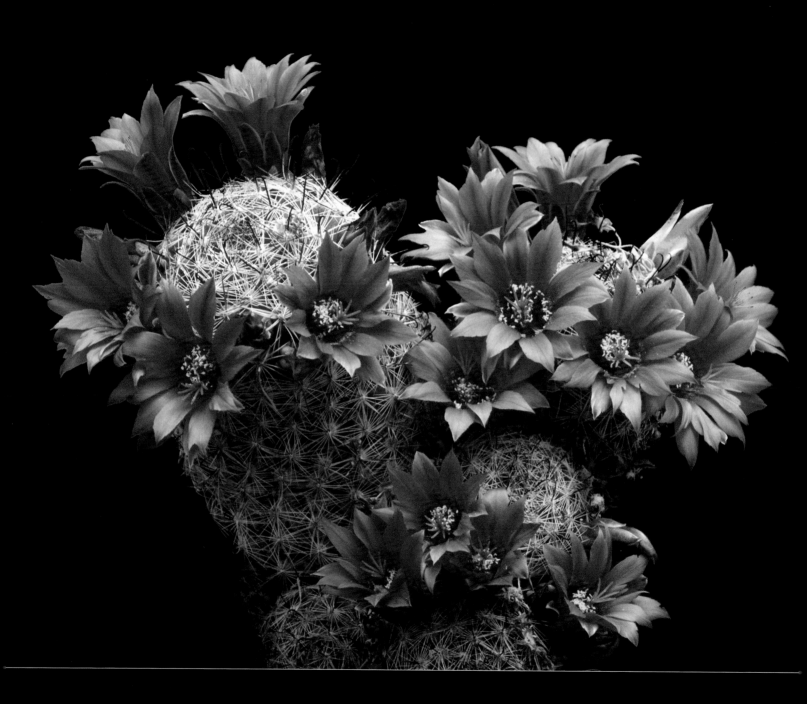

PINCUSHION CACTUS *Mammillaria grahamii*

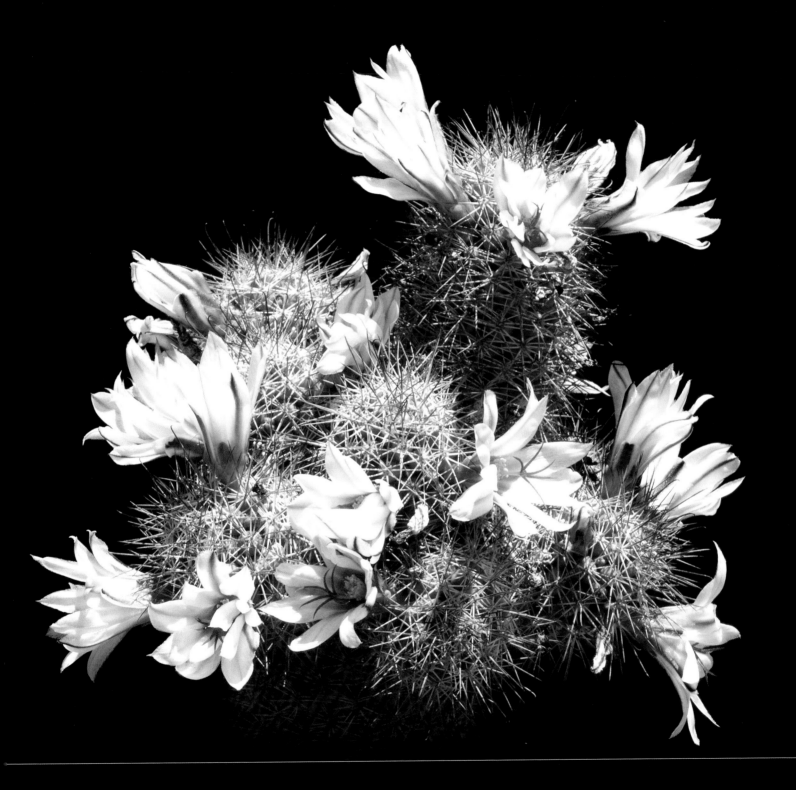

HEDGEHOGS

MARK A. DIMMITT

The stems of some species of *Echinocereus* ("spiny cereus") resemble their namesake animal, but the name is also generally applied to the whole genus. There are 41 species or varieties of hedgehogs in the Sonoran Desert Region. Most species have clusters of densely spined stems to about a foot tall. Other growth forms include stems that are single, nearly spineless, or long and thin.

Hedgehog flowers are typically large relative to the size of the plant, and they include some of the most brilliant colors among our native cacti. The most common color is bright reddish purple, but some species bear flowers that are pink, white, red, or yellow. The flowers of this genus have two unusual traits. The stigmas of most species are bright green. And the buds do not emerge from the areoles; they rupture through the skin of the stem. Hedgehog fruits are juicy, and some are quite flavorful—but it's difficult to find a ripe fruit before the birds and squirrels have gotten to them.

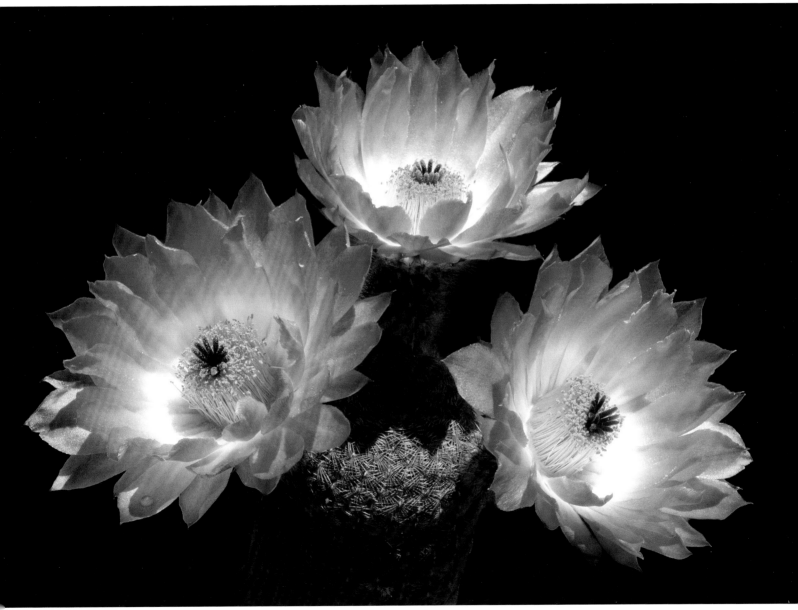

ARIZONA RAINBOW CACTUS *Echinocereus rigidissimus* CABEZA DE VIEJO

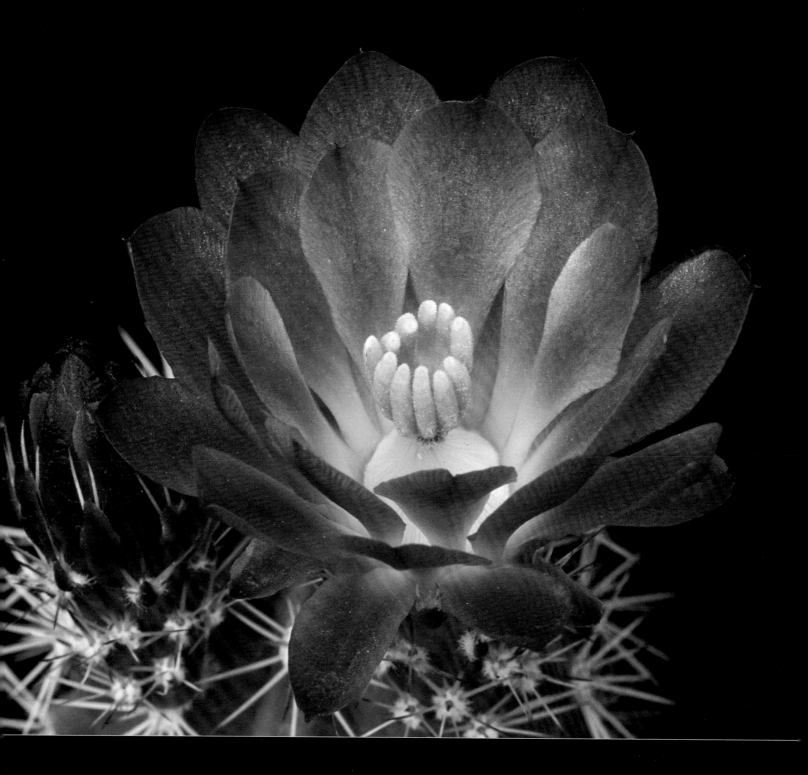

CLARET CUP HEDGEHOG *Echinocereus triglochidiatus*

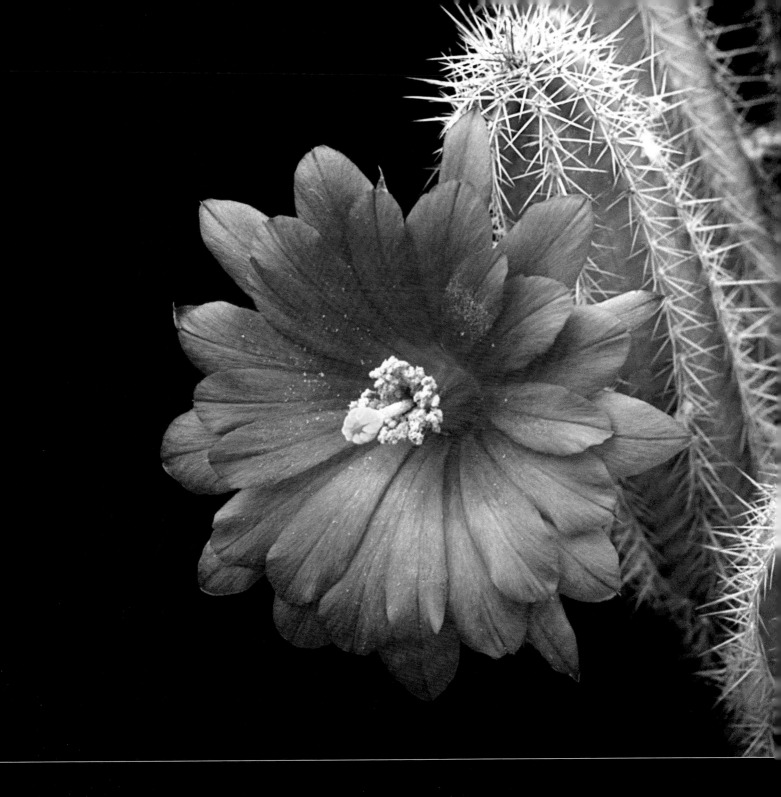

Echinocereus scheeri CHOYITA 43

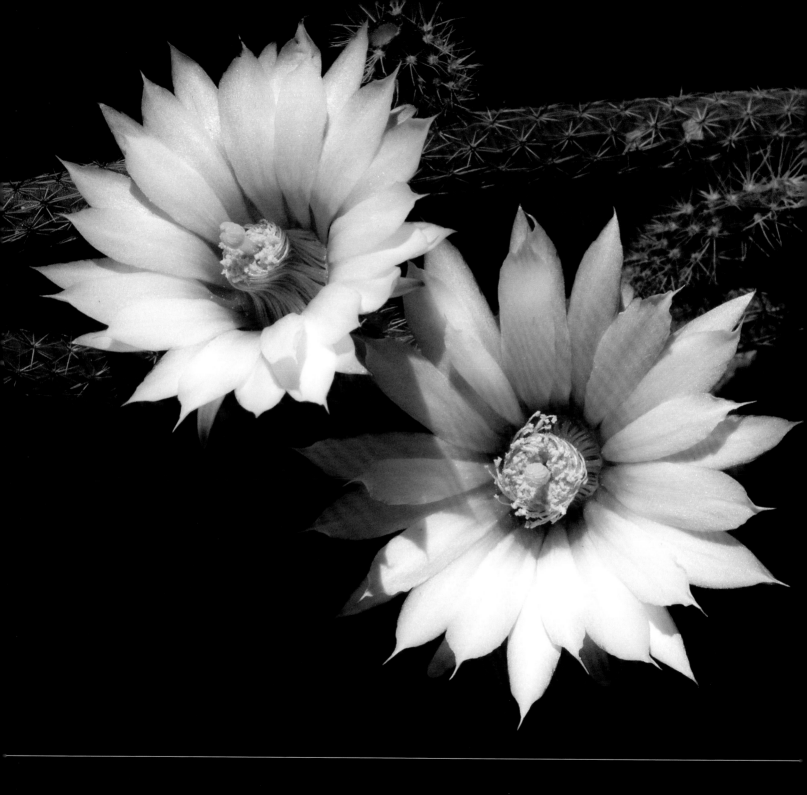

Echinocereus leucanthus

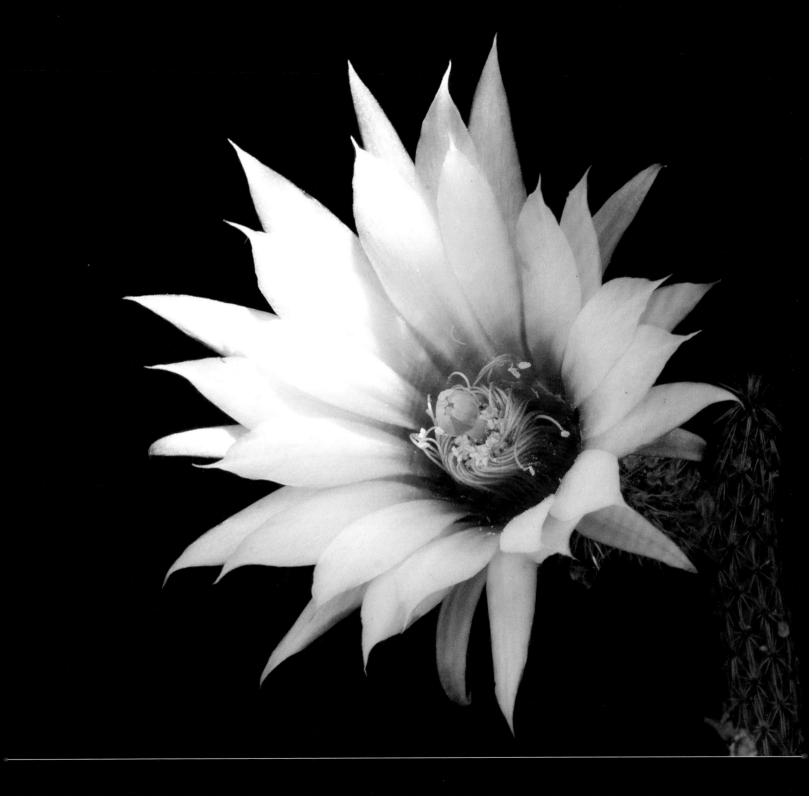

Echinocereus leucanthus

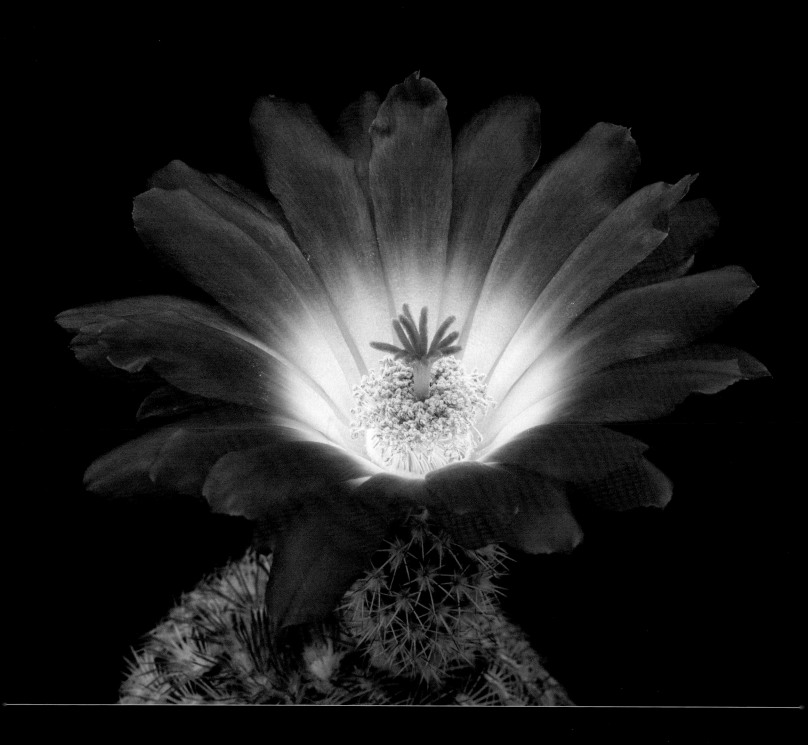

46 Arizona rainbow cactus *Echinocereus rigidissimus* cabeza de viejo

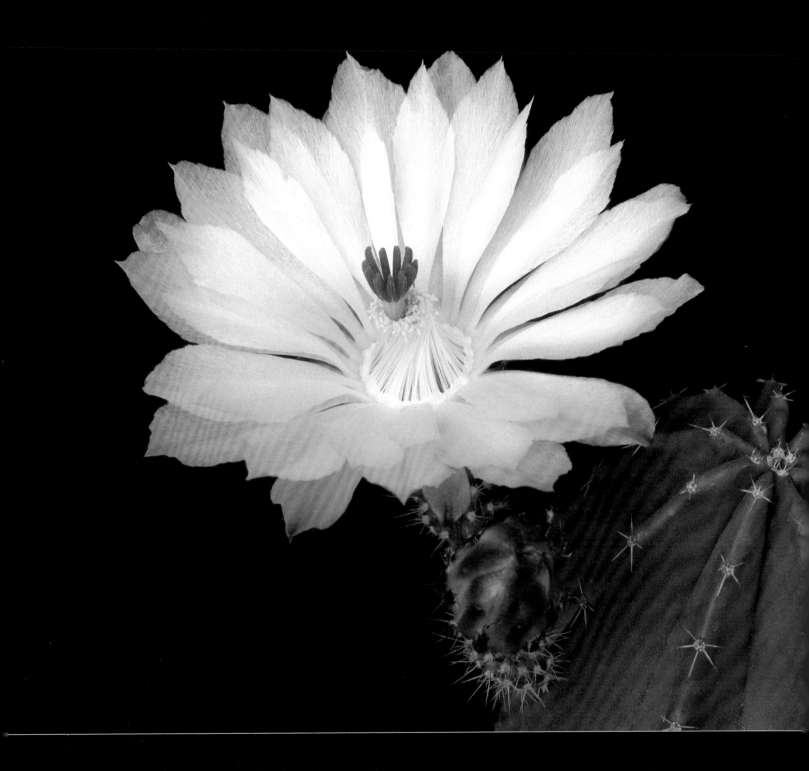

Echinocereus subinermis

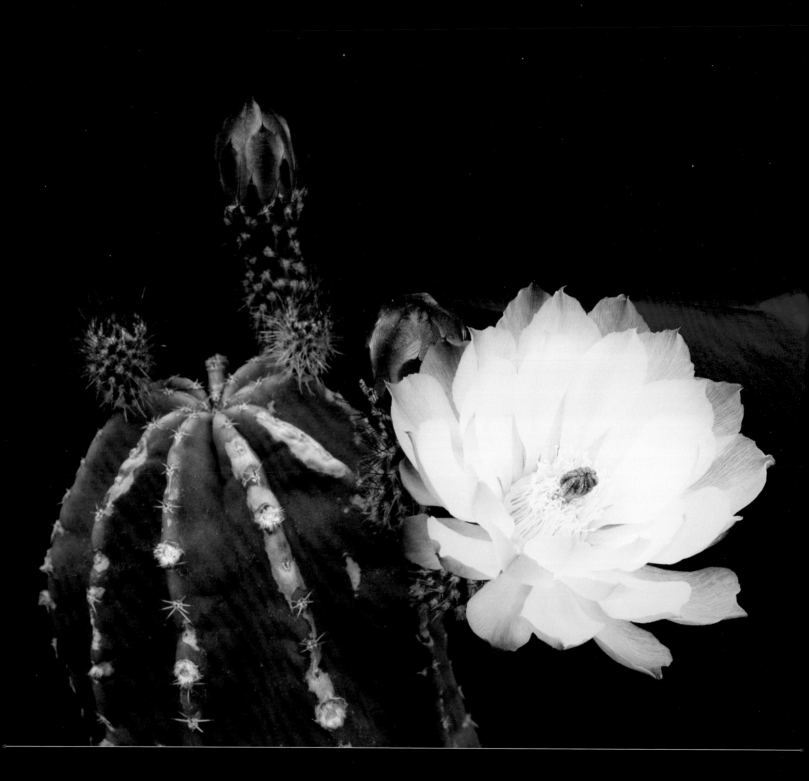

Echinocereus subinermis

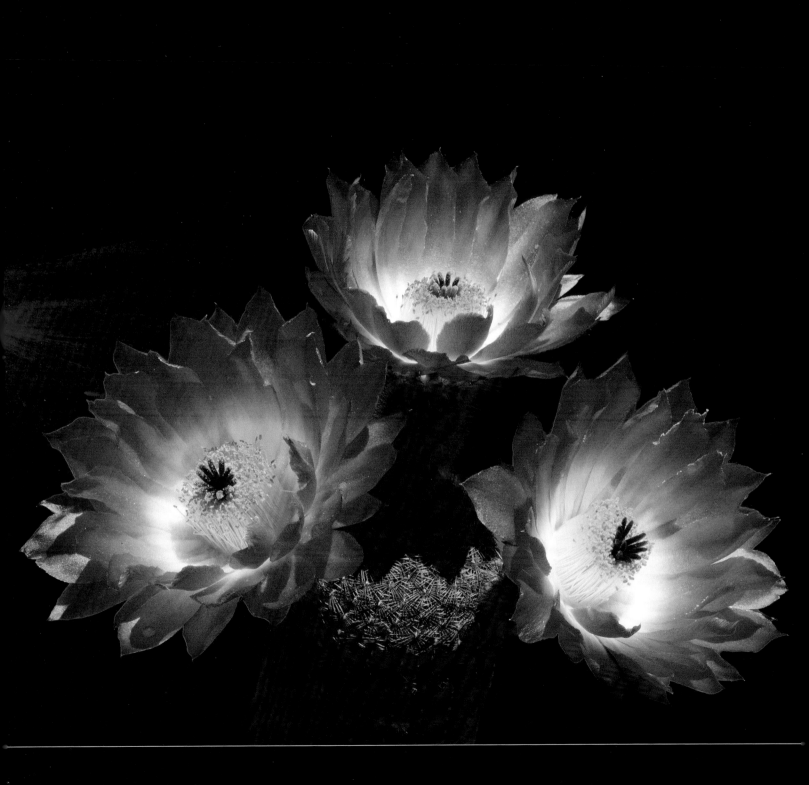

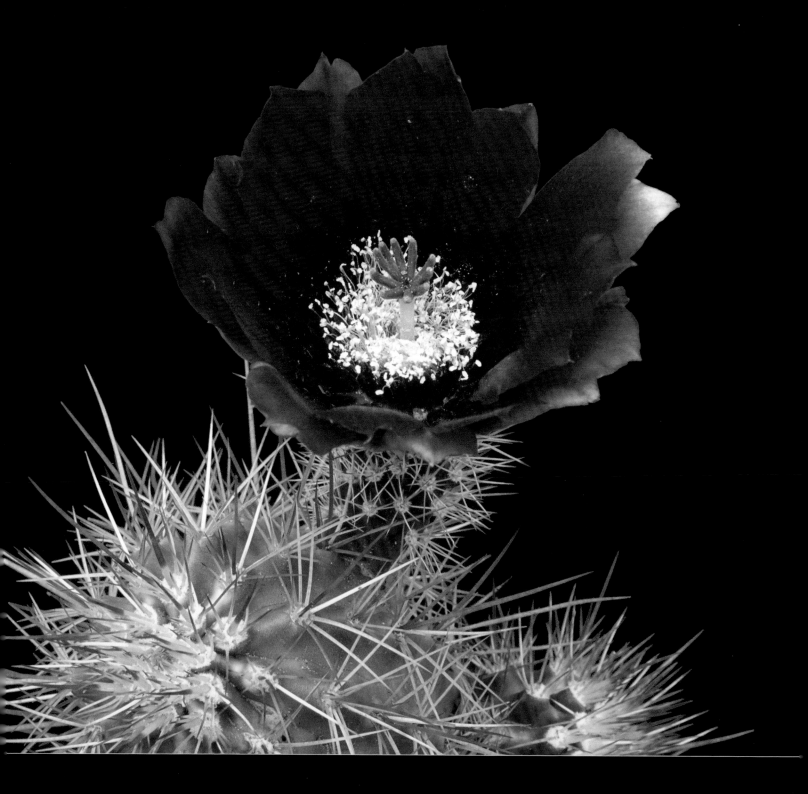

STRAWBERRY HEDGEHOG *Echinocereus engelmannii* SINITA BARBONA

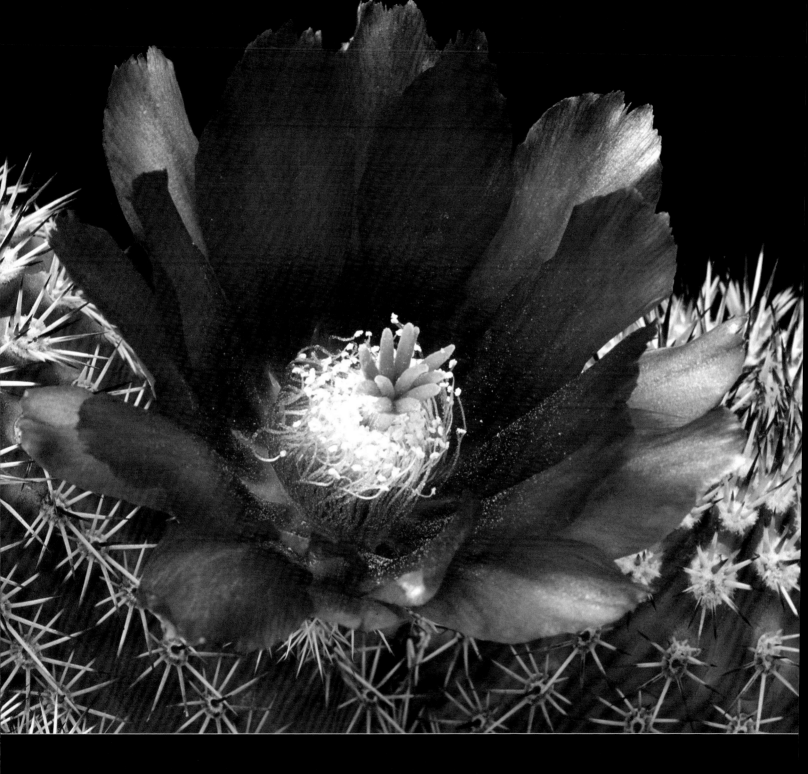

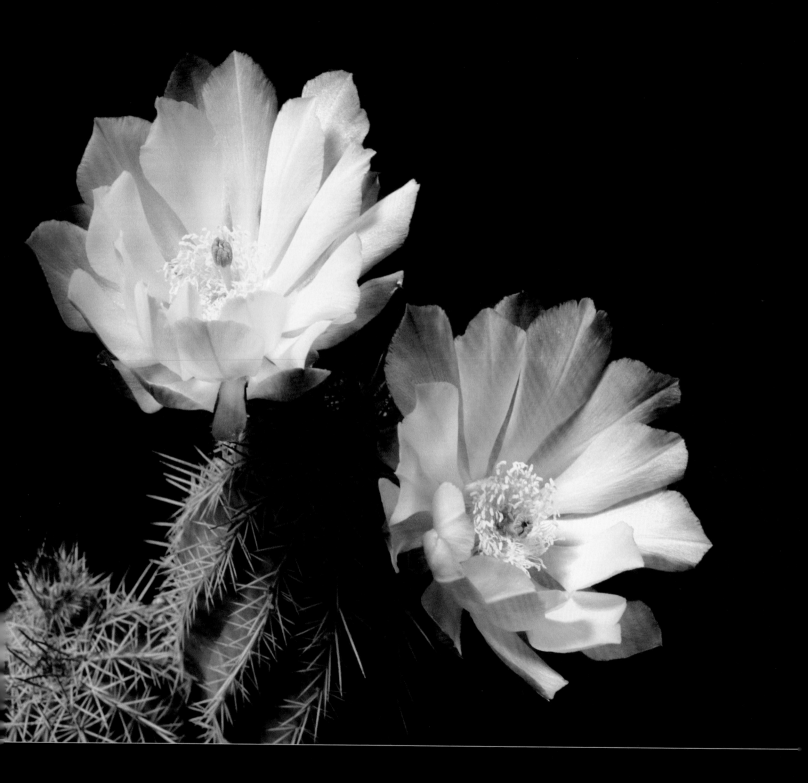

Echinocereus stoloniferus tayopensis CHOYITA

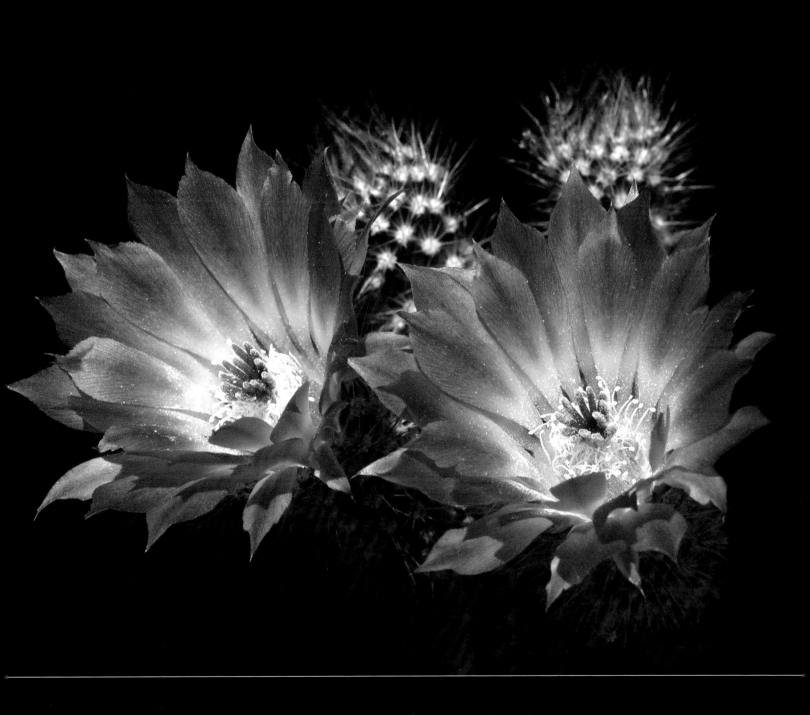

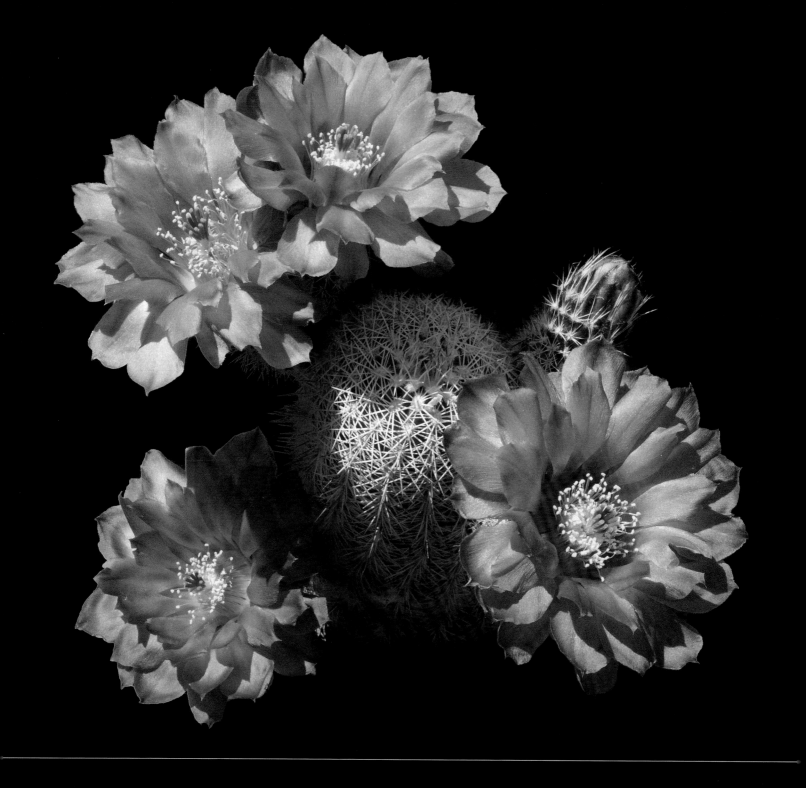

Echinocereus bristolii

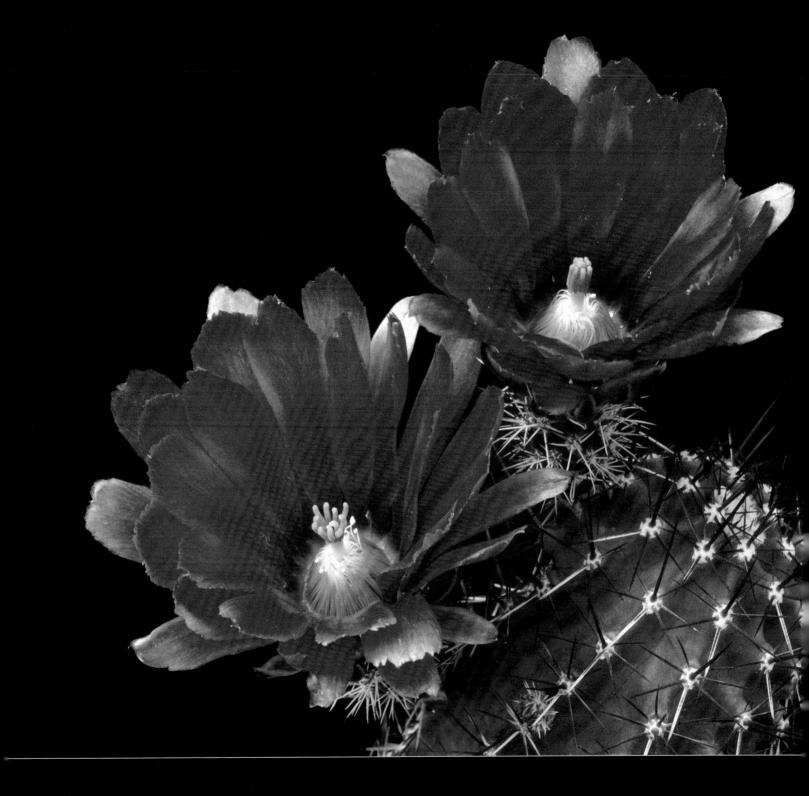

FENDLER HEDGEHOG *Echinocereus fendleri* 55

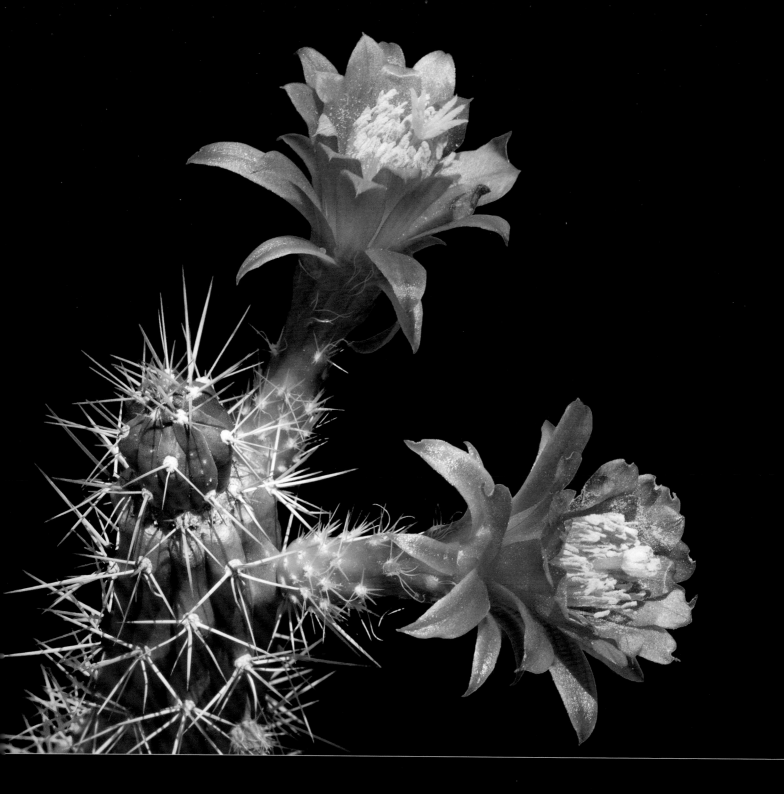

56 HANGING CACTUS *Echinocereus pensilis* PITAYITA

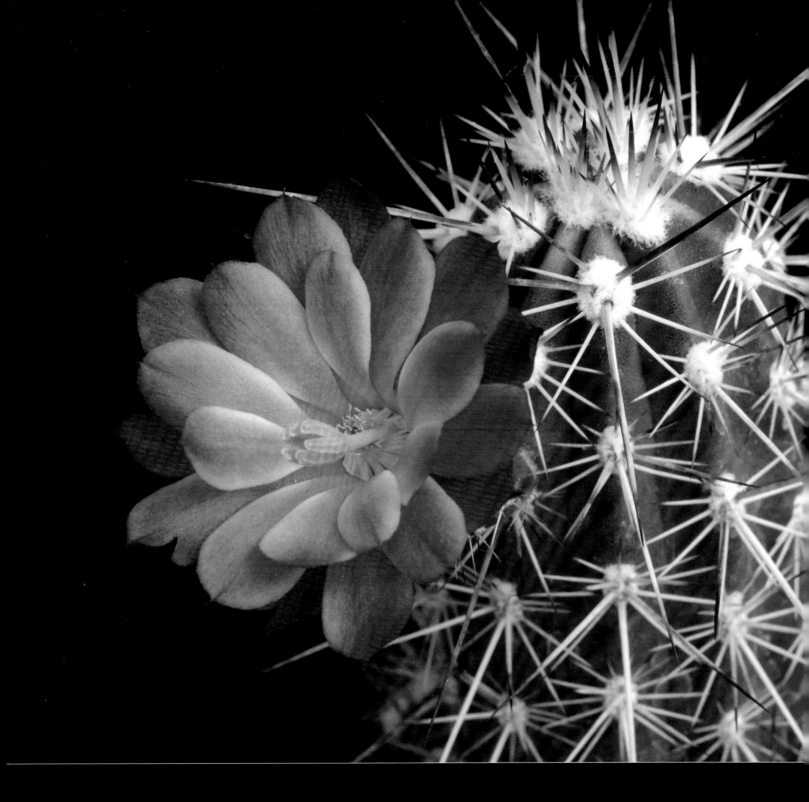

CLARET CUP CACTUS *Echinocereus coccineus* 57

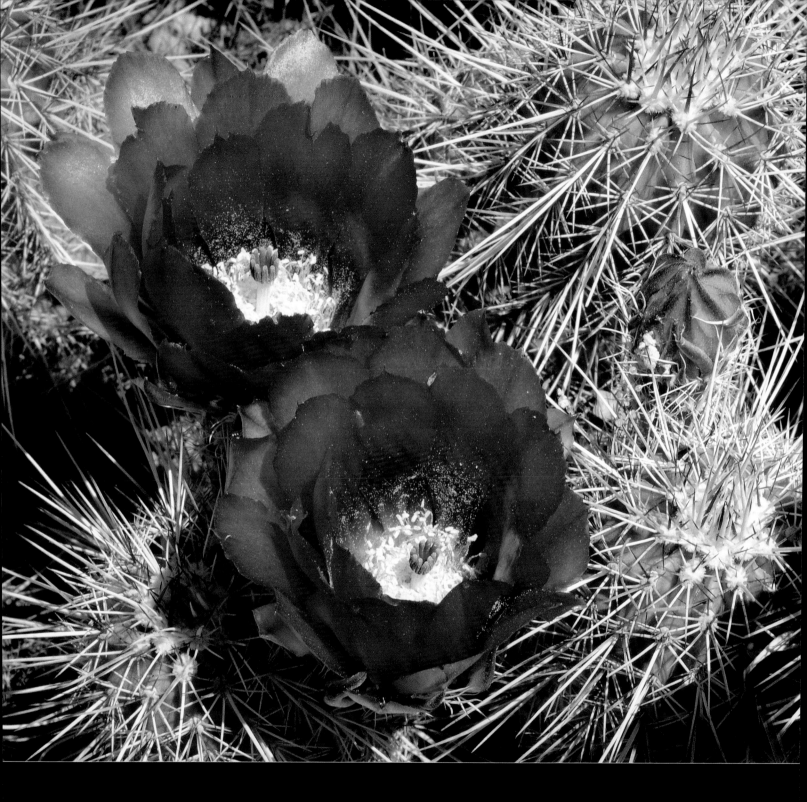

BOYCE THOMPSON HEDGEHOG *Echinocereus boyce-thompsonii*

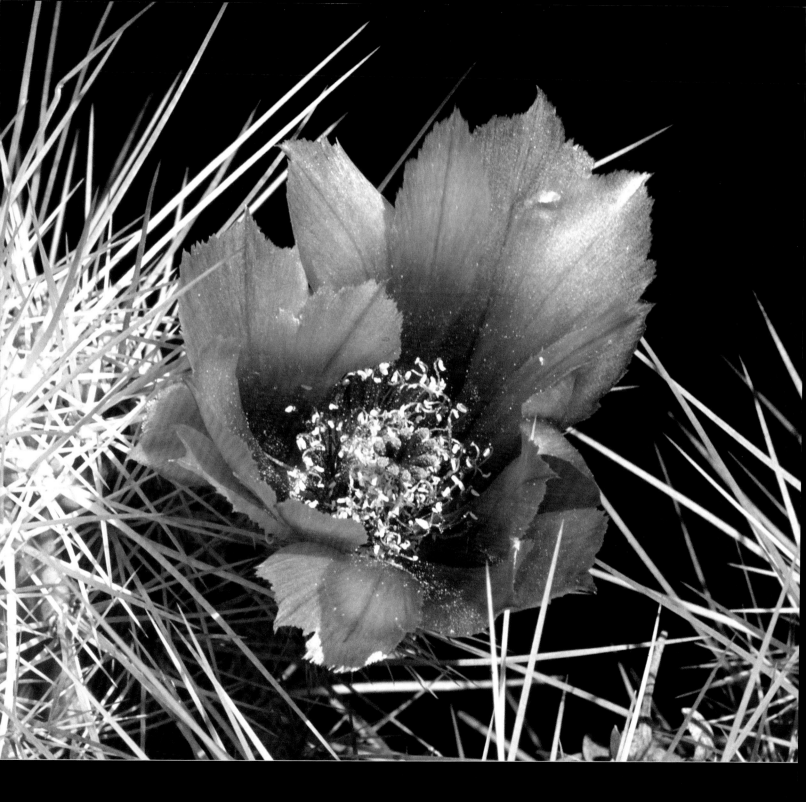

GOLDEN HEDGEHOG *Echinocereus nicholii* 59

OF CACTUS FLOWERS AND FLOWERY PUZZLES

JOHN ALCOCK

L ast week's late-summer thunderstorm provided the wherewithal for a fierce flash flood that surged down the narrow stream in Reavis Canyon before reaching a broader, more substantial wash in the flatland to the south. The flood's handiwork can be seen in the now nearly dry streambed in the form of flattened willow trees, which lie face down, pointing the way south. A remnant trickle of water slips from puddle to basin, and then along a narrow channel carved out of solid bedrock.

When the storm subsided, after the raging stream had stripped plants and soil from the edge of the wash, a blanket of flotsam and jetsam stayed behind to mark the high point of the flood. Here, a brown band composed of little twigs and strands of grass covers whatever managed to avoid being swept downstream. Partly hidden beneath this dull blanket, a pincushion cactus stands bravely upright, just a few inches tall but unfazed by recent events.

In response to the good soaking, the cactus has hurried into reproductive mode, opening dormant flower buds formed several months ago. A dozen or so flowers have pushed aside the grass stalks and spread their petals wide, forming a regal crown on top of the cactus.

The flowers of the pincushion cactus may be small, but they advertise themselves with the exuberance characteristic of many cacti. A crisp rather than cloying pink, some of its flowers are more or less uniform in color, while others feature petals with a darker central strip bordered on either side by much paler bands. The lower cup of the flower surrounds a dense array of bright yellow stamens. The pollen grains that give the stamens their color speckle the interior surface of the cup, while a green stalk with seven spread fingers pokes up through the yellow stamens.

The pincushion's flowers can be rightly appreciated purely for their beauty, but the questions they stimulate are attractive in their

own right. For example, why can this cactus bloom quickly several times a year, provided that decent rains arrive on more than one occasion over the spring and summer? It does not have to be this way. Despite the thorough drenching last week, the saguaros on the hillside in Reavis Canyon will not flower again until next May or June. Moreover, at that time they will produce considerable numbers of flower buds and blooms no matter whether the preceding winter's rains came in December or February, or were heavy or light. In fact, saguaros commonly produce more flowers in dry years than in wet ones! Why should one cactus make flowering completely contingent upon a rainstorm while another does not? I do not know the answer, but I like being aware of the question.

And what of the design of the pincushion flowers? Why does that green stalk with its delicate "fingers" rise above the yellow, pollen-laden stamens? One answer points to

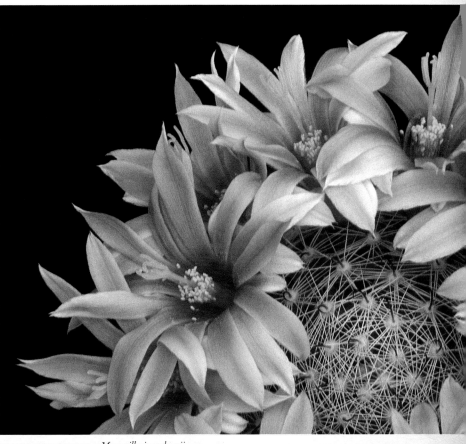

PINCUSHION CACTUS *Mammillaria grahamii*

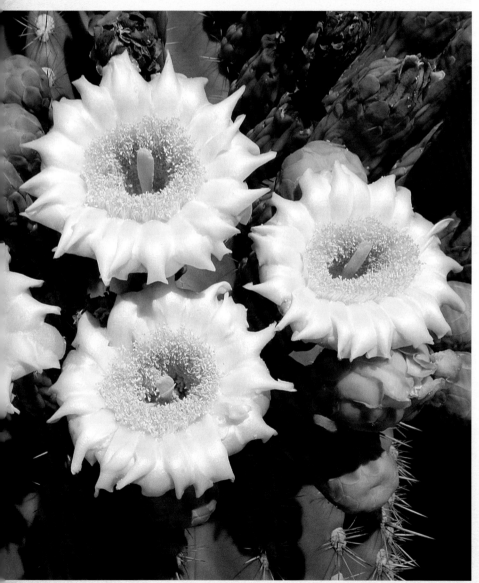

the superior position of the lobes of the green stigma. With pollen-receiving surfaces higher than their stamens, the lobes are unlikely to come in contact with the plant's own pollen. Instead, they will generally be dusted with pollen only when a small native bee plunges into the flower after having visited another pincushion cactus some distance away. Such an arrangement would promote outbreeding, the exchange of genes between individuals, a reproductive tactic widespread (but not universal) among cacti and many other plants.

We could test this idea with the right experiments and some cooperative pincushion cacti, but no one seems to have done this research yet. However, botanists *have* explored the function of saguaro flower design. The shiny white flowers of this species are much larger and more conspicuous than those of the diminutive pincushion cacti hiding under the local fairy dusters and bursages. Even so, the basic structure of the saguaro flower is remarkably similar to that of its tiny relative. The saguaro bloom also consists of a symmetrical array of outward-opening petals that surround a central mass of stamens, from which emerges a substantially taller stalk with an upper surface receptive to pollen. To test whether the saguaro is unconsciously trying

to outbreed, botanists have bagged saguaro flowers so that their stigma can only receive pollen provided by the researchers themselves. Some of the bagged flowers are then given a chance to outbreed after being hand-dusted with pollen taken from another saguaro. About half of these specimens go on to develop mature fruits. Other bagged flowers are hand-pollinated using the plant's own pollen, and these blooms almost universally fail to produce fruits.

The results of this simple experiment are illuminating; they confirm that outbreeding is really the only option for this species, an option made possible by wide-ranging pollinators that visit a whole series of saguaros. A Mexican long-tongued bat (*Choeronycteris mexicana*) whose snout has become covered in saguaro pollen during its travels—or an Africanized honeybee worker packing pollen on its hairy hind legs—inadvertently applies a stranger's pollen to that part of a saguaro flower willing and able to respond to genetic material from another saguaro.

Someday a botanist may do a comparable experiment with pincushion cactus flowers, probably confirming that this species, like its huge relative, reproduces strictly by outbreeding. If so, we will have an answer to one question about its highly aesthetic flowers, while leaving us with plenty of others for our contemplative pleasure. We might consider why pincushion cacti make flowering dependent upon rainfall. Is pink the color that the pincushion's bee pollinators find most attractive? Are some native bees better pollinators than others, more committed to visiting pincushion cacti to the exclusion of other nectar- and pollen-producing plant species? What are the pincushion pollinators doing during the often long intervals between rains when the little cacti stand flowerless in the desert? It's nice to know that we still have questions to answer about the inconspicuous pincushion, one of many cactus species of the Sonoran Desert, each one with its unique natural history, each offering us puzzles to solve as well as gorgeous flowers to admire.

JOHN ALCOCK is an Emeritus Professor in the School of Life Sciences at Arizona State University (Tempe). He has spent much of his adult life studying the mating behavior of Sonoran Desert insects and is the author of a number of books, including *Sonoran Desert Spring* and *Sonoran Desert Summer*, on the natural history of this most extraordinary desert.

OPUNTIOIDS

MARK A. DIMMITT

Prickly pears and chollas are collectively called opuntioids; some botanists place nearly all of the species in the genus *Opuntia*. They are easy to recognize by the stems that grow in discrete units called joints (scientifically speaking, "cladodes"). Prickly pears (most species are in *Opuntia* in the narrow sense) have flattened joints or pads, which are often mistaken for leaves. Our current count is 47 taxa (species, varieties, and hybrids) in the Sonoran Desert Region. Chollas (genus *Cylindropuntia*) have cylindrical joints. They comprise the largest cactus genus in the region, with 66 taxa. There are also eight species of club chollas, alternately placed in *Grusonia* or *Corynopuntia*; botanists can't make up their minds.

Unlike other cacti, all opuntioids have tiny barbed spines called glochids as well as typical cactus spines. The glochids of most species detach easily, and can cause intense itching that many consider to be worse misery than the pain inflicted by the larger spines. Opuntioids also have true leaves in the form of small fleshy fingers on young joints. In all of our species, the leaves fall early on, leaving only the spines that are in fact modified leaves. The barbed spines of chollas are covered by papery sheaths that protect the sharp tips from weathering—a gentle tug will remove these sheaths, leaving the spines naked.

Opuntioids and a few other cacti exhibit a behavior that aids pollination. (Yes, plants have behavior too.) The flowers have thigmotrophic stamens—they move in response to being touched. In an undisturbed flower the stamens are spread out, forming a bowl of pollen-covered anthers. When a bee lands in the midst of these hundreds of stamens, the filaments bend inward toward the center, enveloping the bee in a tight cylinder of pollen. It must force its way out of this embrace, a process that ensures it will be well covered with pollen. This is beneficial to both participants in the cooperative behavior. The bee collects lots of pollen to feed its grubs (larvae), and some of it is transferred to other flowers the bee visits to produce seeds. In a few minutes the stamens open again, waiting for the next visitor. A finger will trigger the same response, although the bees are so thorough in their work that it is usually difficult to find an unvisited flower.

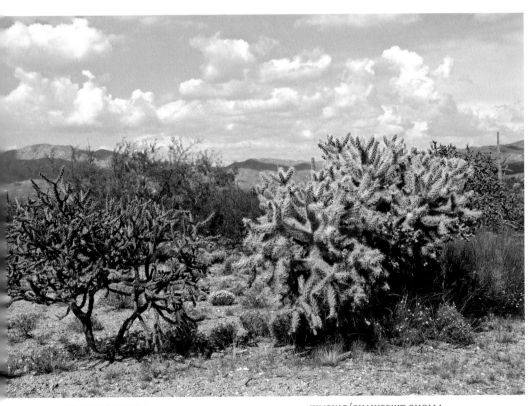

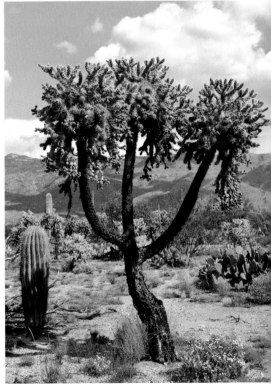

STAGHORN CHOLLA JUMPING/CHAINFRUIT CHOLLA JUMPING/CHAINFRUIT CHOLLA

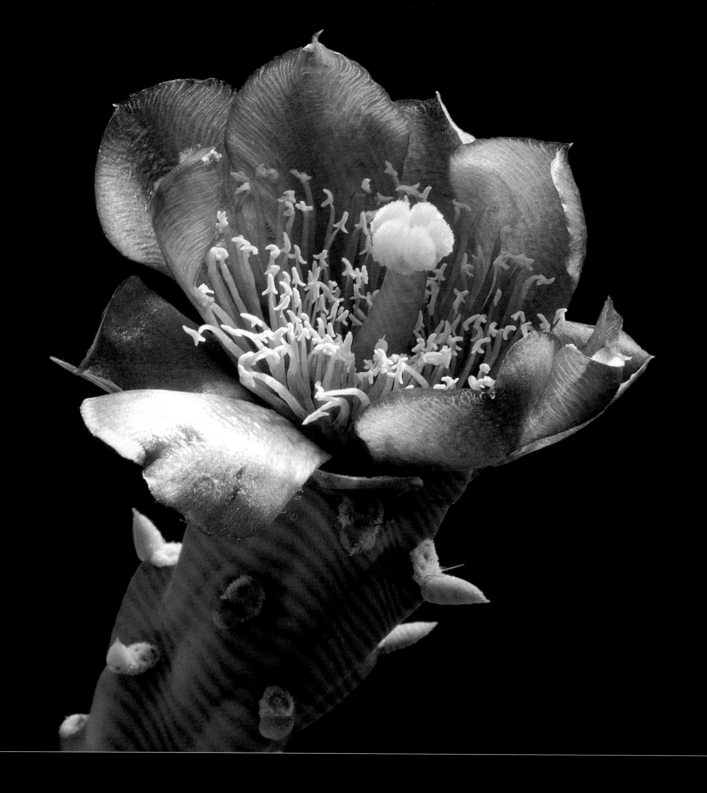

PENCIL CHOLLA *Cylindropuntia arbuscula*

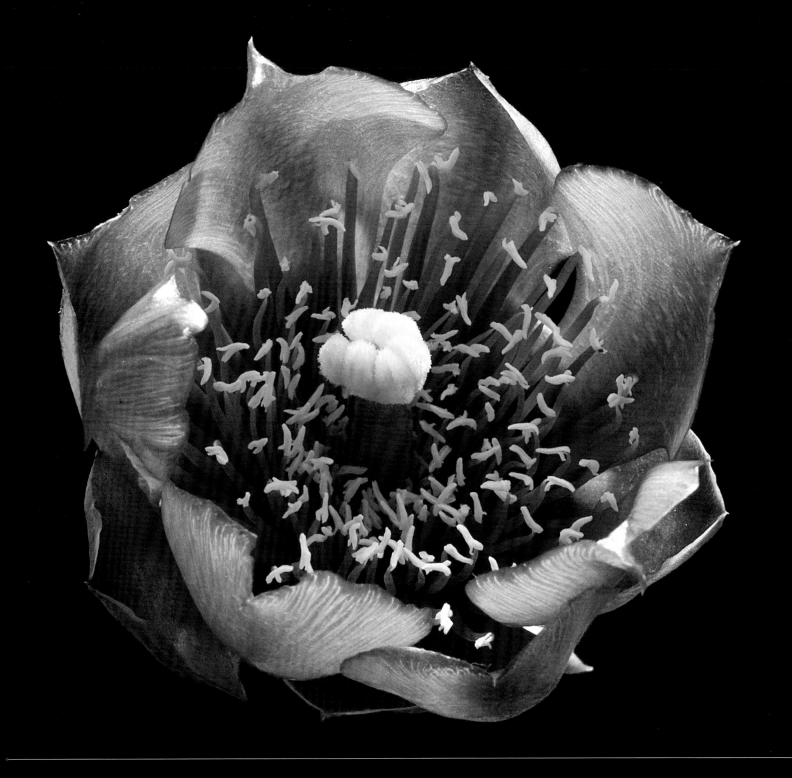

PENCIL CHOLLA *Cylindropuntia arbuscula* 67

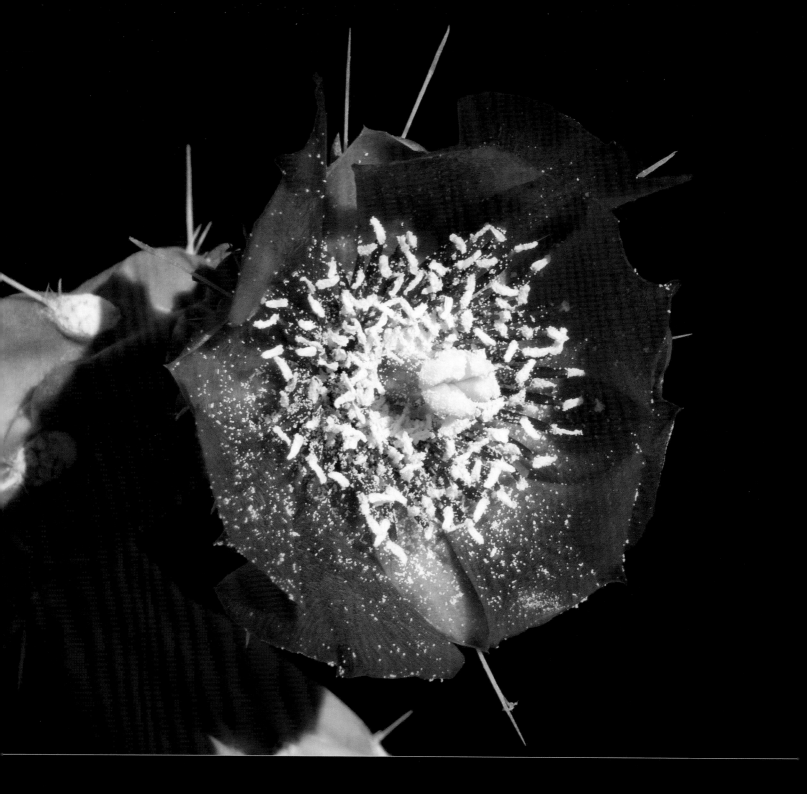

CANE CHOLLA *Cylindropuntia imbricata* CHOYA

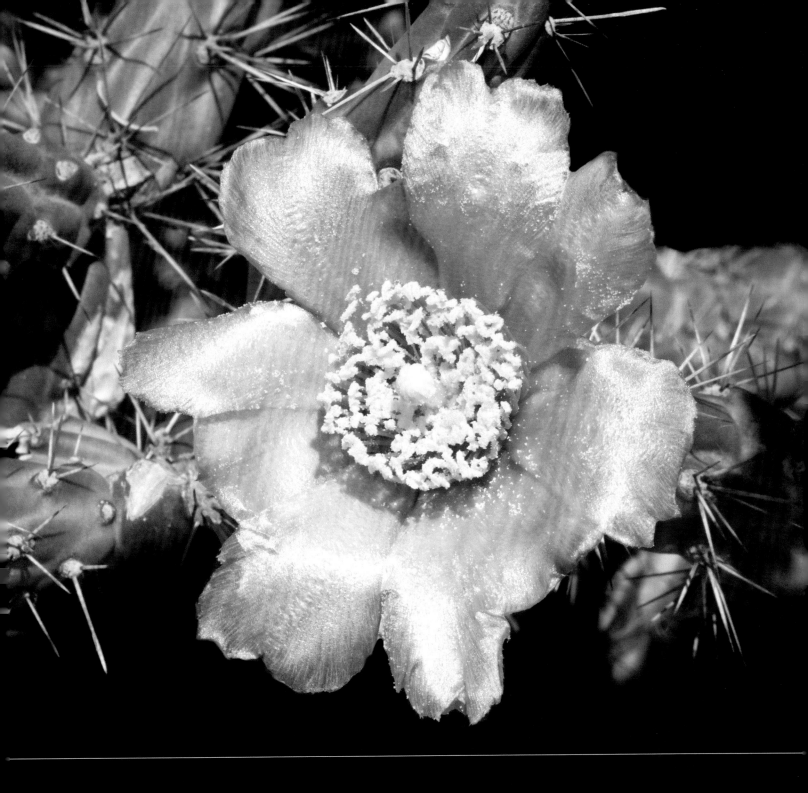

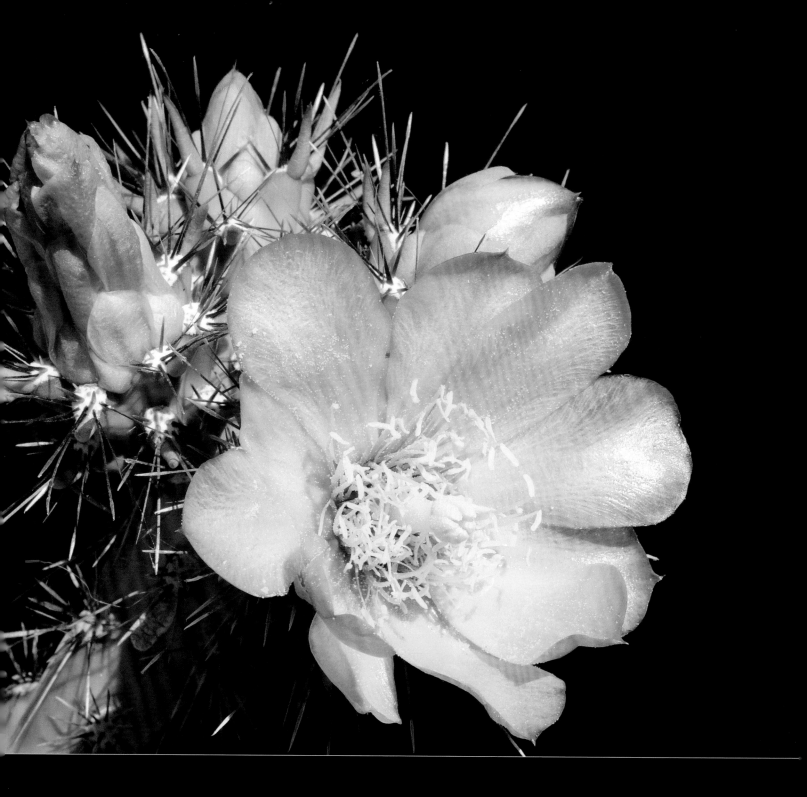

BUCKHORN CHOLLA *Cylindropuntia acanthocarpa* CHOYA

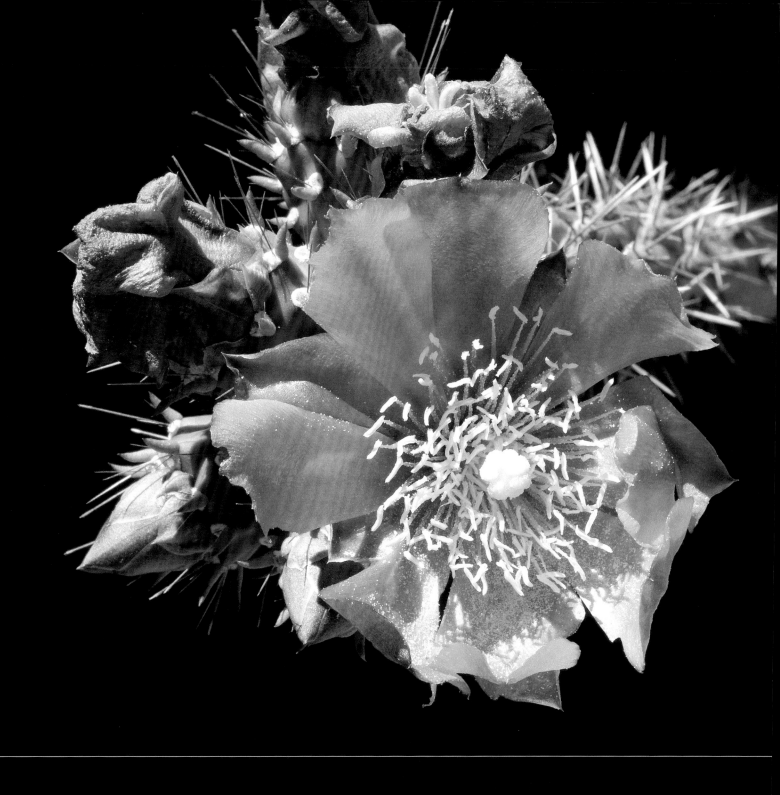

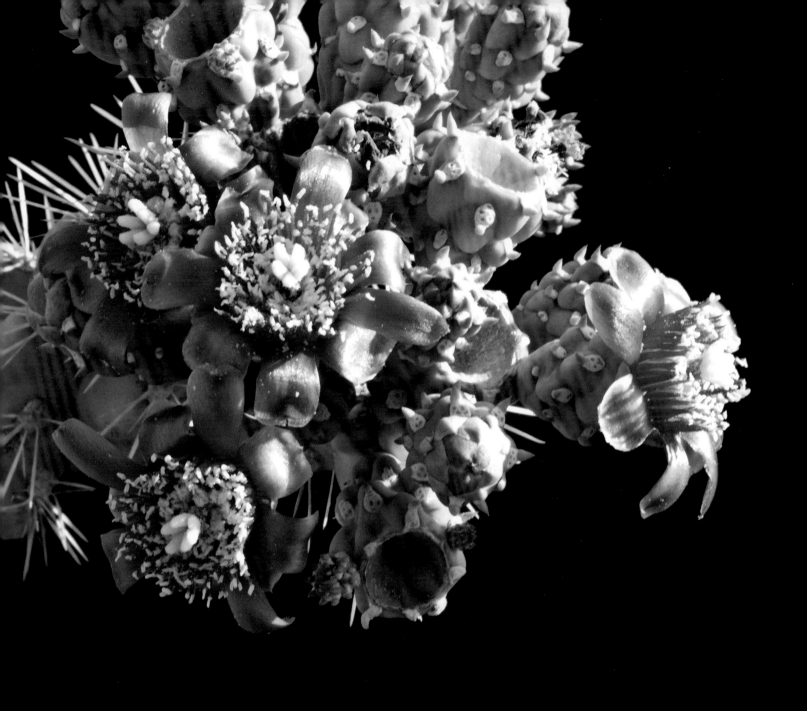

CHAINFRUIT CHOLLA *Cylindropuntia fulgida* CHOYA

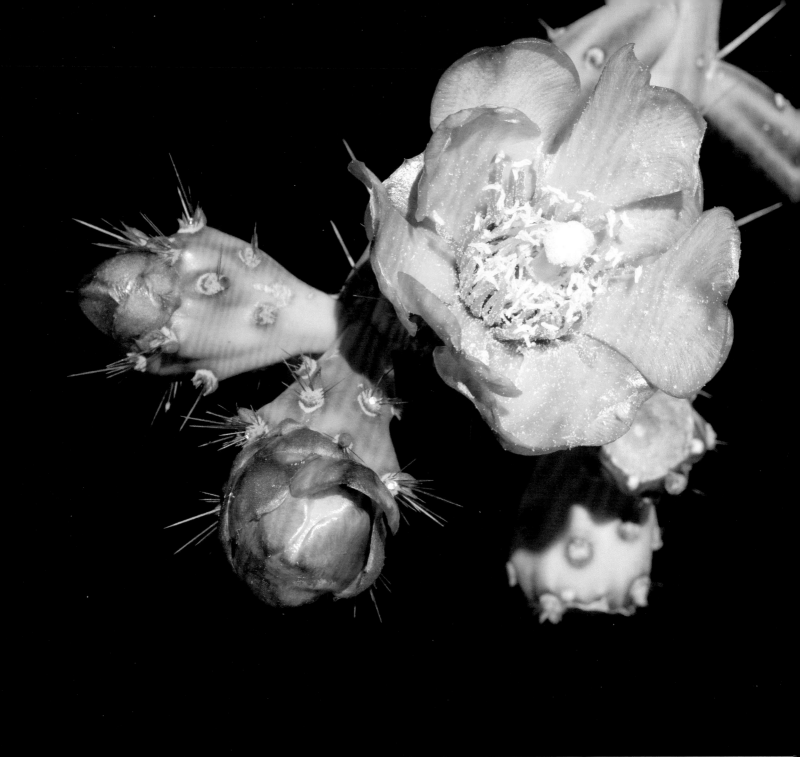

STAGHORN CHOLLA *Cylindropuntia thurberi versicolor* CHOYA

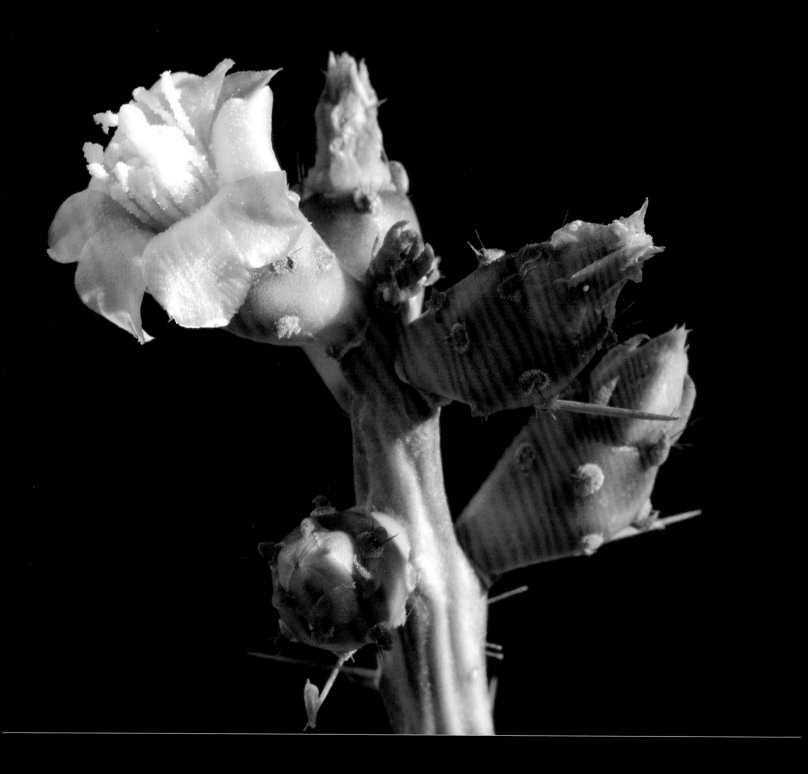

Christmas cholla *Cylindropuntia leptocaulis* TASAJILLO

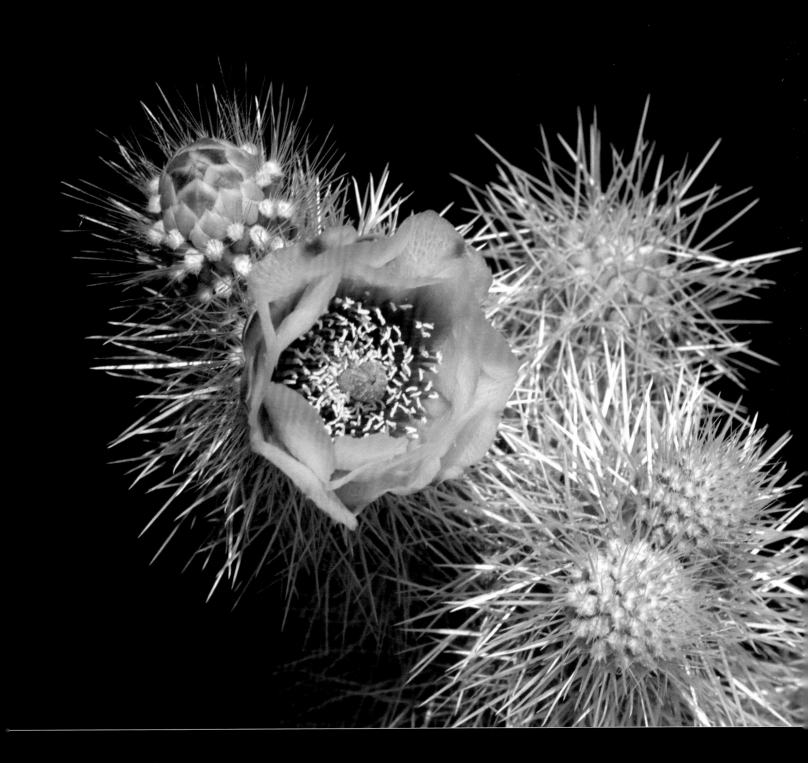

TEDDY BEAR CHOLLA *Cylindropuntia bigelovii* CHOYA GÜERA, VELAS DE COYOTE 75

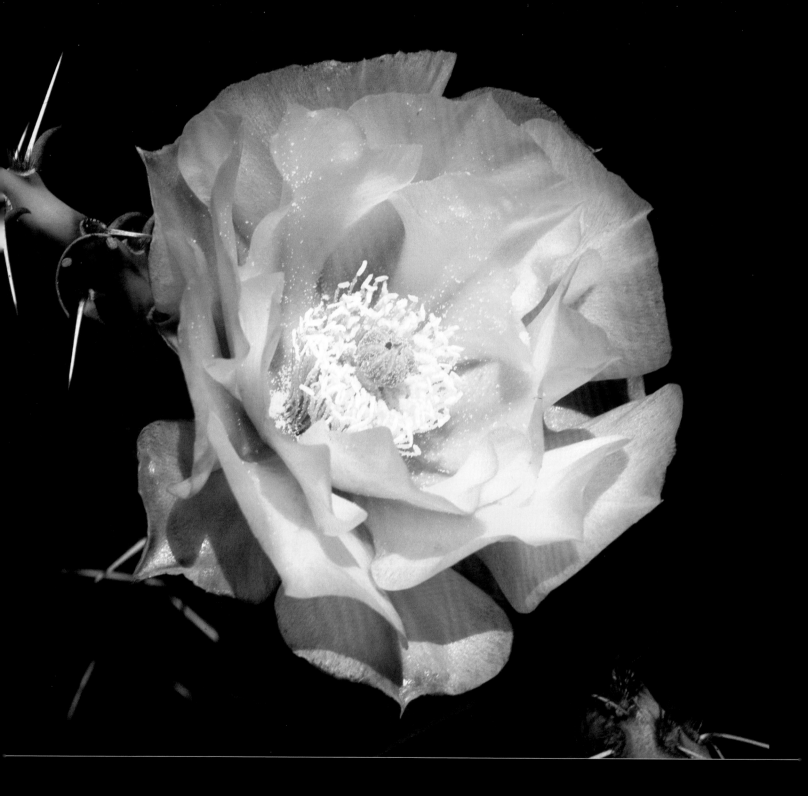

Engelmann prickly pear *Opuntia engelmannii* NOPAL

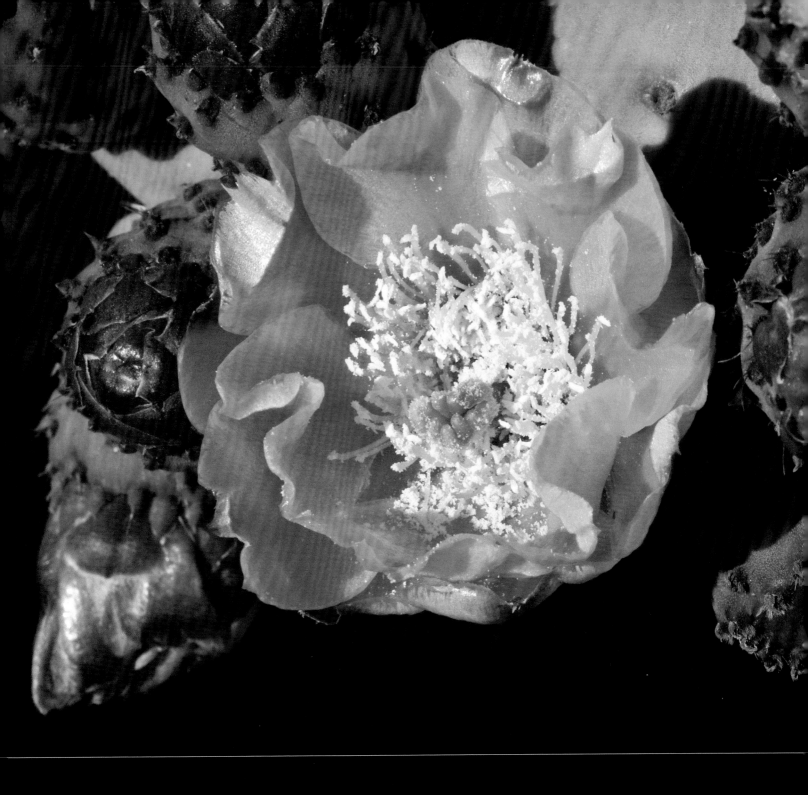

INDIAN FIG *Opuntia ficus-indica* NOPAL DE CASTILLA 77

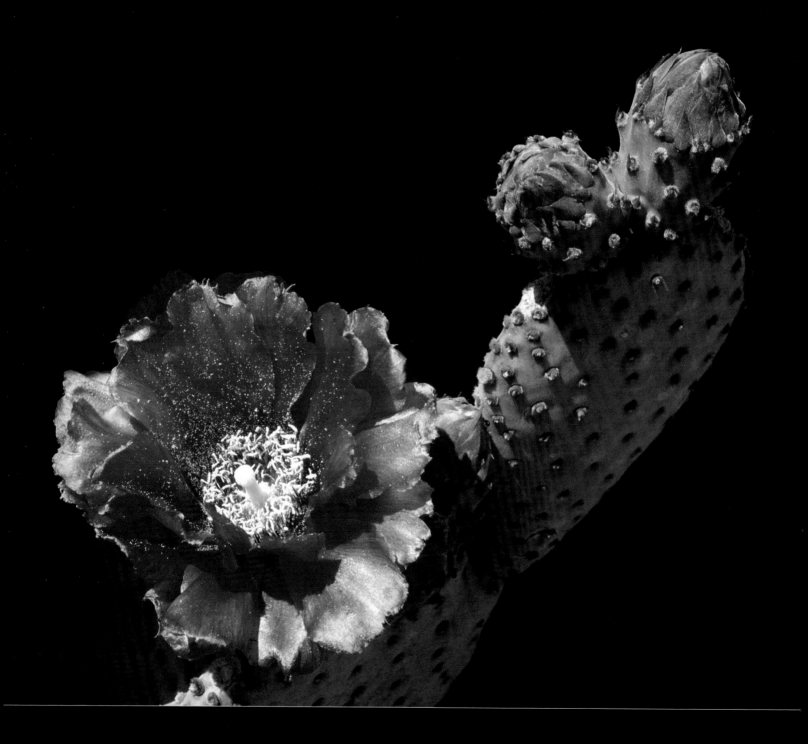

BEAVERTAIL CACTUS *Opuntia basilaris* NOPAL

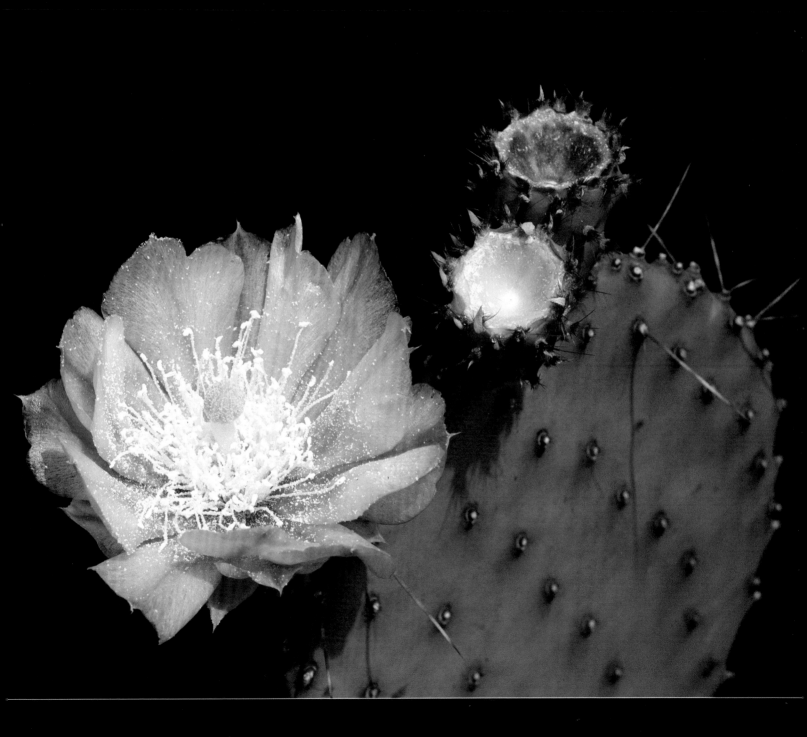

SANTA RITA PRICKLY PEAR *Opuntia santa-rita* DURAZNILLA 79

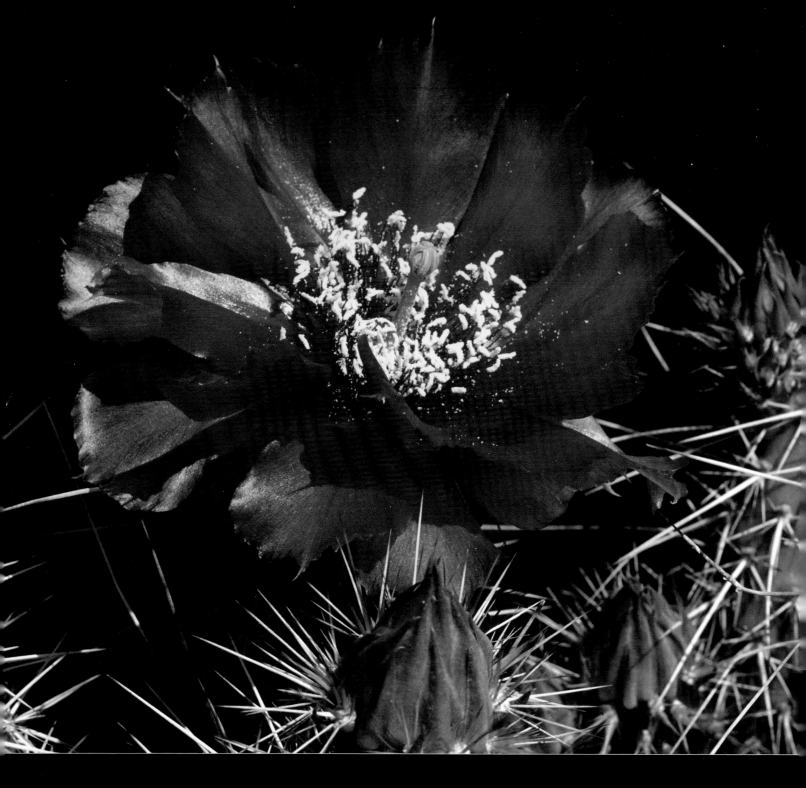

GRIZZLY BEAR PRICKLY PEAR *Opuntia erinacea ursinus*

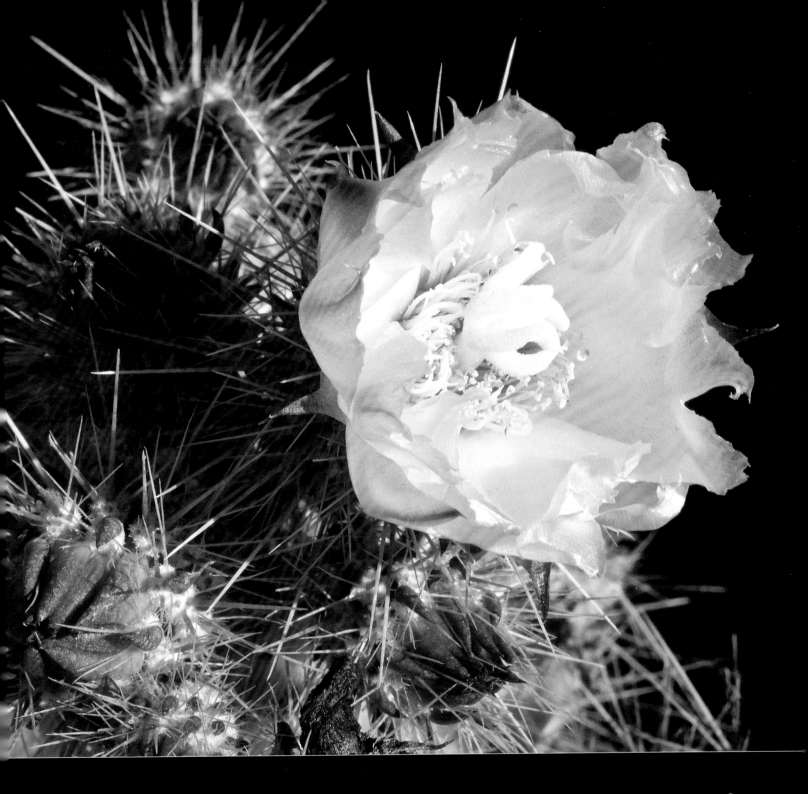

DEVIL'S CLUB CHOLLA *Grusonia emoryi*

COLUMNAR CACTI

MARK A. DIMMITT

While the other groupings of cacti in this book reflect levels of biological and evolutionary reality, the category "columnar cacti" is an unscientific classification based simply on appearance: all of its members have very long, cylindrical stems. Columnar cacti belong to several different evolutionary lines, although all are within the cactoid subfamily. Most of the North American species share the ecological trait of being pollinated by nectar-feeding bats. The bat-pollinated species have large, whitish flowers. As always in the natural world, there are exceptions. Senita is pollinated by a small moth, and sina is pollinated by hummingbirds.

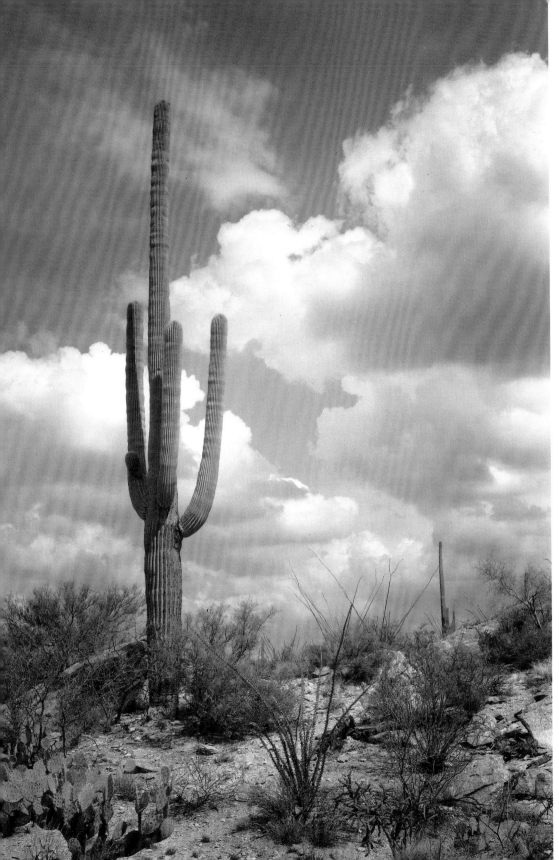

SAGUARO
Carnegiea gigantea
SAHUARO

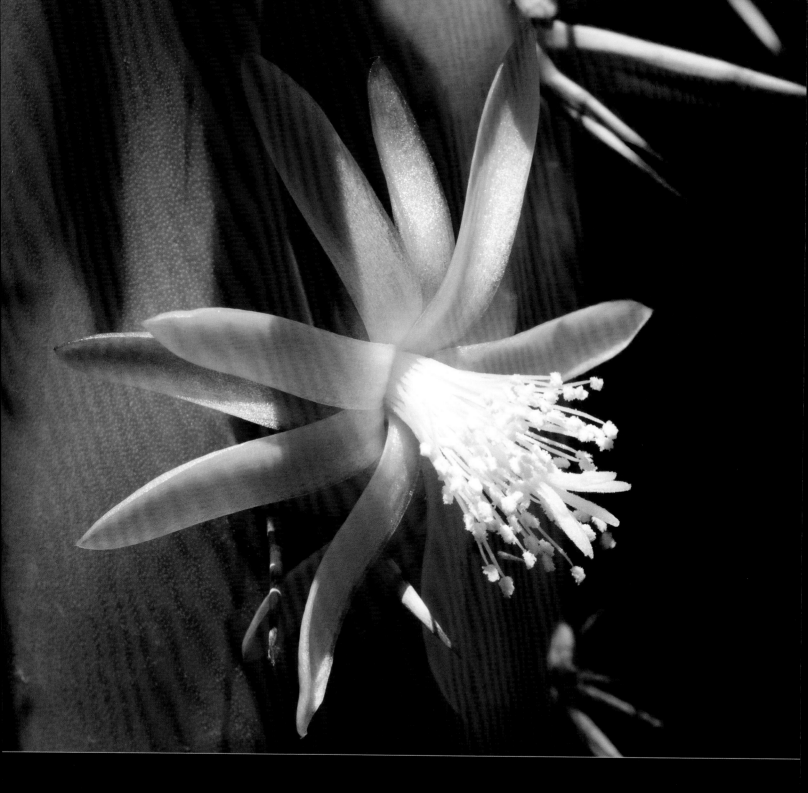

CANDELABRA CACTUS *Myrtillocactus cochal* COCHAL

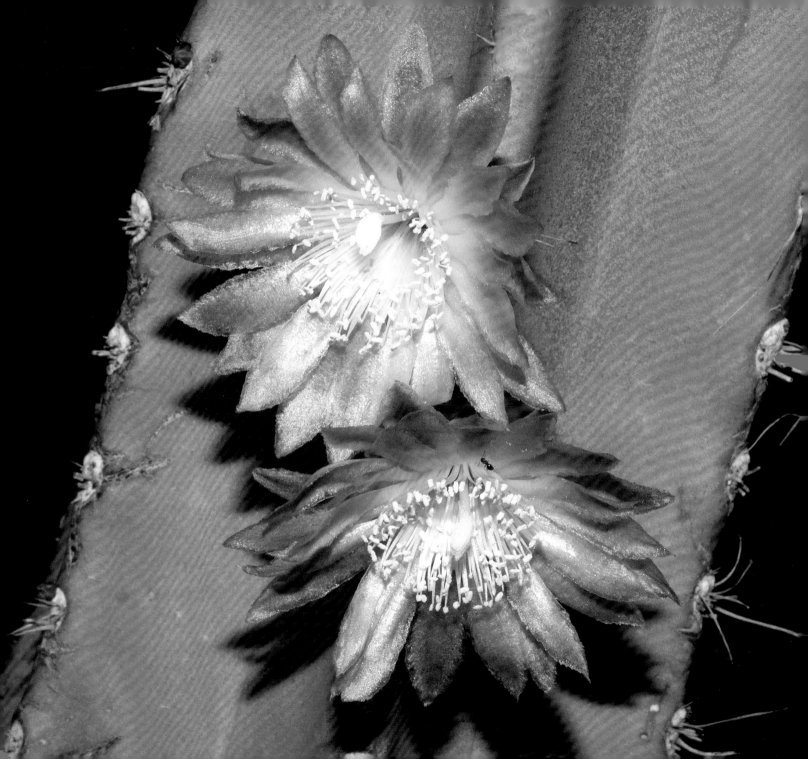

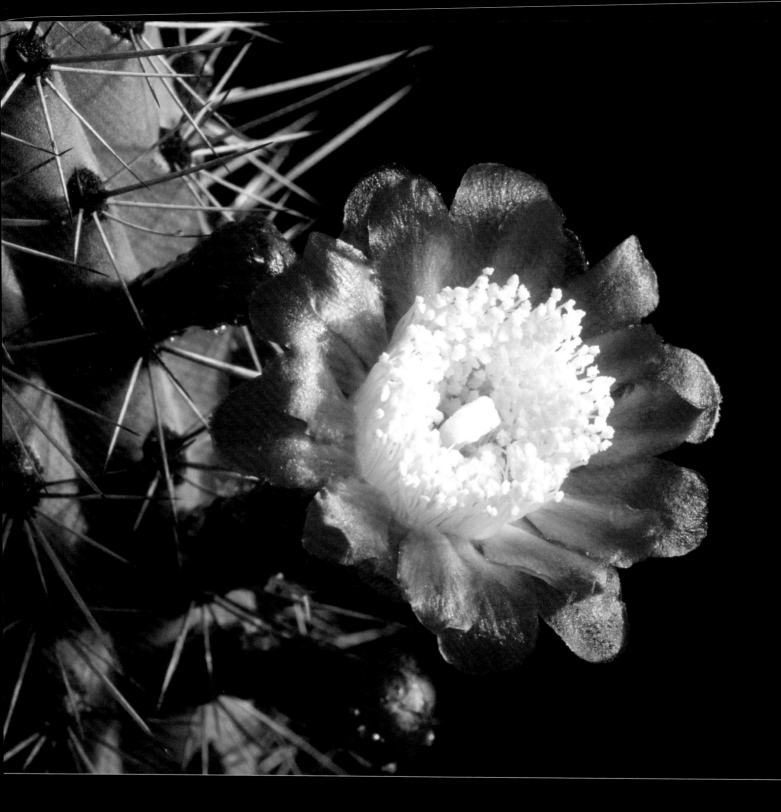

86 DWARF ORGAN PIPE CACTUS *Stenocereus littoralis*

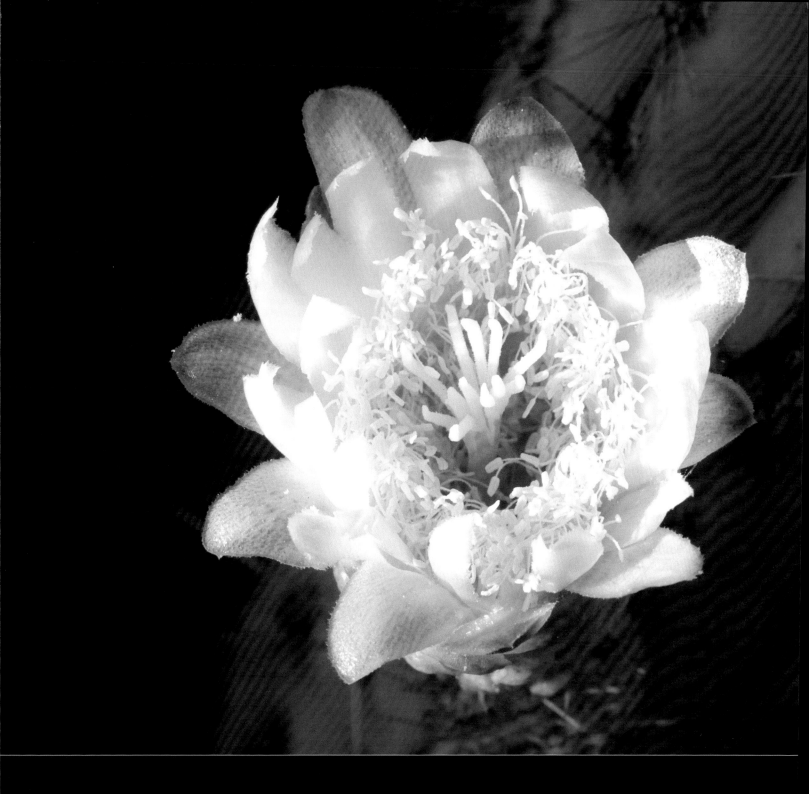

ORGAN PIPE CACTUS *Stenocereus thurberi* PITAHAYA 87

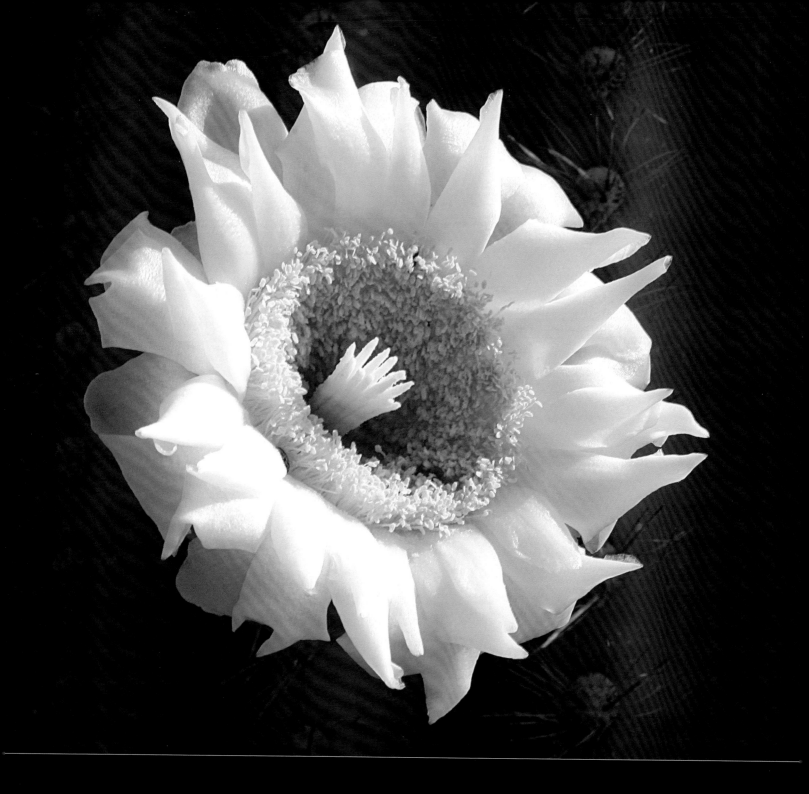

88 SAGUARO *Carnegiea gigantea* SAHUARO

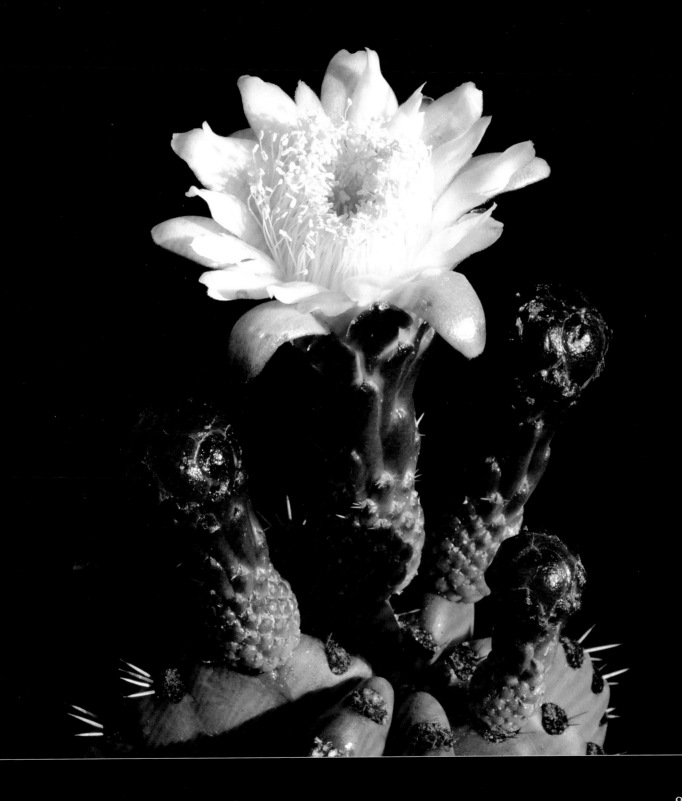

Stenocereus montanus SAHUIRA

THE GREENHOUSE

JOHN JANOVY, JR.

Had he not died in 1973, *A Desert Illuminated* would be a perfect gift for my father, who among his many obsessions—stamps, music, coins—eventually added still another, this one the most addictive of all: cactus. His children could not have waited for a birthday or other scheduled event for buying it. No, John Schaefer's magnificent photography would have to have been acquired quickly, before my father heard about it from a friend, or noticed an advertisement in one of the several publications he received regularly to feed his curiosity about succulents. In March he'd received a death sentence—pancreatic cancer—but at the same time he was given something of enormous value: six months to live completely free of any obligations to his profession, that of petroleum geologist. With the right combination of drugs he could buy the time to become, at least in his own mind, one of the many things he probably wished he'd become in the '30s—namely, a botanist, a serious, professional botanist.

By 1973 his cactus collecting had given way to a far more challenging self-imposed obsession—to grow various species from seed to flower. So how did he use his gift of time? To build a greenhouse for his plants. We rarely talked about the flowers he hoped to produce, but in cleaning out his belongings after he and the six months of total freedom were gone, my sister and I eventually got to the closet full of 2 x 2 slides in plastic boxes. There were his flowers, in old-fashioned Kodachrome, each labeled with date, time, place, and scientific name. He had traveled the desert Southwest to take these pictures, obviously at the expense of his business. I have no idea to whom he showed these slides, but he was clearly intent on capturing something that presents itself to the world almost exclusively in the wild, and even then, often only for a short time. These pictures will be valuable in some way, I thought, loading them in the trunk of my car.

Sure enough, a quarter-century later as a university biologist given a near-impossible

teaching assignment, I dug around in my own closet for those same slides. The course was titled "Biodiversity," but it actually covered a lifetime's worth of organismic biology in fifteen weeks. Pre-med students need to see and understand cactus flowers, I decided, for a whole gamut of reasons.

The lesson of those Kodachromes remains a powerful one; there are elements of nature that are almost impossible to domesticate, and those phenomena can be possessed only if allowed to thrive, on their own schedule, in their own genetically determined way, in the settings to which they are adapted. Nobody gets on the Internet and orders a dozen *Mammillaria* species' flowers for someone's birthday. No, if you want those flowers you have to go find them at the right time, in the right place, and once you've found them, there is something about them that says, "Leave me alone; I don't belong in your hand."

Nowadays, out in the Nebraska Sandhills with my students—most of whom have come

to the field station for a quick, four-credit summer program and a good letter of rec-ommendation—we stop at every flowering cactus, an *Opuntia* species or *Escobaria vivipara* (the low-growing spinystar cactus). Out come the pocket digitals. I stand back and watch as twenty young adults re-enact what my father did so many years ago—taking pictures of cactus flowers. When they've finished, I ask myself, "Do I need more pictures myself?" Inevitably, the answer is, "Sure, why not; the flower won't be here next week; I can't see it in my yard back home; and electronic images cost nothing compared to Kodachromes." Will this behavior change with the publication of John Schaefer's magnificent photography? No, but the thoughts will; no longer will I consider electronic images free.

The scientific literature on cactus flowers is filled with studies on pollination, and the list of pollinators is itself a description of New World desert biota. Prevailing paradigms in biology demand that flower-pollinator inter-

actions be explained evolutionarily, with many classic examples from several plant families illustrating tight, even quite wondrous, relationships worthy of a nature documentary. But two mysteries surrounding cactus flowers seem to have no easy solutions. First, why are these flowers so complex and variable structurally; and, second, why is there so much pollination activity around them, when reproduction in so many cactus species is primarily vegetative, a process in which pollination has no place.

The first question is perhaps best answered by saying, simply, "Because they're cactus." Such an answer invokes an evolutionary explanation, something akin to saying that primates have pentadactyl handlike appendages because their ancestors did. In other words, whatever happened back when modern cactus diverged from their *Pereskia*-like ancestors, that divergence involved the diversity and increased structural complexity of flowers, along with stem succulence. If you're a cactus, then you have highly complex flowers that are not easily dissected, nor obviously suited for either introductory textbook diagrams or explanations of sex. Thus, the reason you can't go out into your garden and pluck an *Opuntia* flower to use in a dining room table centerpiece, or to explain fertilization to your child, might be somehow related to environmental conditions in the place where cacti first evolved.

The reason for all this pollination activity—all those bees, bats, and tiny birds sucking nectar and spreading cactus genes all around the neighborhood—seems obvious at first. If you live in an inhospitable place, you need to produce lots and lots of potential offspring, in other words massive numbers of seeds, to survive as a species. Alternatively, you need to find some other way to reproduce—for example, by dropping off fertile pieces of your body that then take root if they end up in the right place. Cacti exhibit a bewildering array of reproductive and mating strategies, only some of which follow the expected scenario of flowering, pollination, seed development and germination. Again, the scientific literature is instructive in the number of so-called mating systems in cactus species. With this in mind, we might view cactus flowers with a certain amount of suspicion; we might wonder what they really are showing us. Are they sterile? Are they male sterile only? Have they appeared too early, too late? Do they have the same number of chromosomes as flowers that look, to us, identical, and just as compellingly beautiful? Finding the answers might well take years, if not a career's worth of research.

For most of us, however, the answers to scientific questions are subordinate to capturing the images, both mental and photographic. For me, having seen some of these flowers on

wild plants, having gone to their place for that express purpose (instead of trying to bring them into my own yard) multiplies the impact of Schaefer's photographs. He has come as close as anyone can to actually giving us the intellectual jolt that comes from seeing truly extreme beauty in a natural setting. The world is not all freeways, flat buildings, semis on the interstate, text messages, wide-screen televisions, car bombs, and political stridency. No, there are, out there in the desert, some of the most delicate, ephemeral, and stunningly handsome reminders of what the planet has produced, all on its own, without our intervention, and would continue to produce, for eons, if we'd just leave it alone.

Finally in this cleaning, after packing up the 2 x 2 slides, we get to the greenhouse—built entirely by hand by my father from plans and drawings made as soon as he could lift a pencil after surgery—a greenhouse finished just about on schedule, all complete, working and full of small plants, at about the same time he became too weak to walk. He was pushed out there in his wheelchair, a cigarette in hand, over the Oklahoma red clay, just to sit and look at his handiwork. There are the old antifreeze cans, from back when antifreeze came in metal containers, all washed carefully, and all filled with various soil mixtures. The labels on these cans reveal a mind at work; to get his flowers from seeds, he would have to reconstruct the land from which the cactus came. My sister and I toss the contents out into a creek that runs outside the back fence.

Thirty-five years later, I envision a different scenario. If this trip out to the greenhouse in the wheelchair had taken place today, I would have gently lifted the cigarette from his broad hand, and placed a copy of *A Desert Illuminated* on his lap. Then he would have his flowers—his enormously complex, highly variable, ephemeral, almost impossible to study, yet magnificently beautiful cactus flowers.

JOHN JANOVY, JR. is the Paula and D. B. Varner Distinguished Professor of Biological Sciences at the University of Nebraska-Lincoln. His research is focused on the ecology of parasites. His 14 books include *Keith County Journal*, *Vermilion Sea*, *On Becoming a Biologist*, *Teaching in Eden*, *Outwitting College Professors*, and *Foundations of Parasitology* (with Larry Roberts); and the screenplay for the televised version of *Keith County Journal* (Nebraska Public Television). Dr. Janovy has received many honors, including the University of Nebraska Distinguished Teaching Award, *American Health* magazine book award (for *Fields of Friendly Strife*), University of Nebraska Outstanding Research and Creativity Award, the Nature Conservancy Hero recognition, and the American Society of Parasitologists Clark P. Read Mentorship Award.

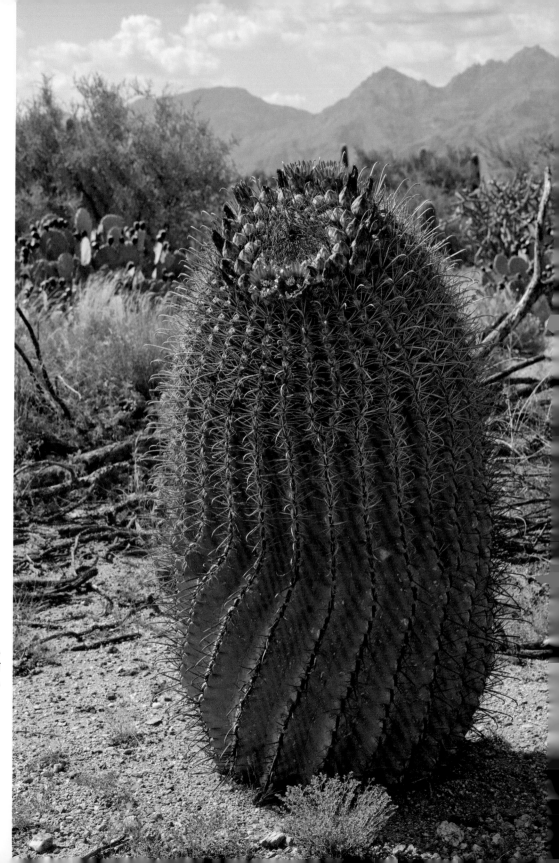

FISHHOOK BARREL
Ferocactus wislizeni
BIZNAGA

BARRELS

MARK A. DIMMITT

The name "barrel cactus" is used for a number of massive, mostly single-stemmed cacti. In the Sonoran Desert Region barrels belong to one of two genera, *Ferocactus* or *Echinocactus*. Most are not only large, but are also armed with particularly stout and often interestingly shaped and textured spines. ("Fero" means fierce, or ferocious.) Some species have straight spines, others are adorned with sharp and dangerously hooked spines. The spines may be round or flattened in cross section, and most are adorned with rough, raised transverse ridges and rings that are conspicuous to the touch. Spine variations are helpful in distinguishing among the 27 species and varieties (and one hybrid) of *Ferocactus* in the Sonoran Desert Region. *Echinocactus* differs from *Ferocactus* in having woolly stem tips. We have only two *Echinocactus* species in our region, a single-headed one (*E. horizonthalonius* var. *nicholii*) and a clustering one (*E. polycephalus*).

Barrel cacti are prominent in desert lore as a source of life-saving water for people stranded or lost in the Southwest. While indigenous peoples can extract usable water from many barrel species, most others would be quite helpless. First, you must be able to distinguish among the species, because one of them is toxic. Second, you need long-handled, sharp tools to cut through the very tough spines and skin. Third, you need the skill to accomplish the task efficiently so you don't lose more sweat than you will recover from the barrel. Fourth, you need to have the good fortune to be lost where there are barrels to cut; they don't grow throughout the desert. Fifth, you must also be lucky enough not to be stranded during a drought, or the pulp will be more like a damp sponge than a juicy watermelon. However, if you're sufficiently prepared and clever enough to get water from a barrel cactus, you probably had the foresight to bring plenty of water in the first place.

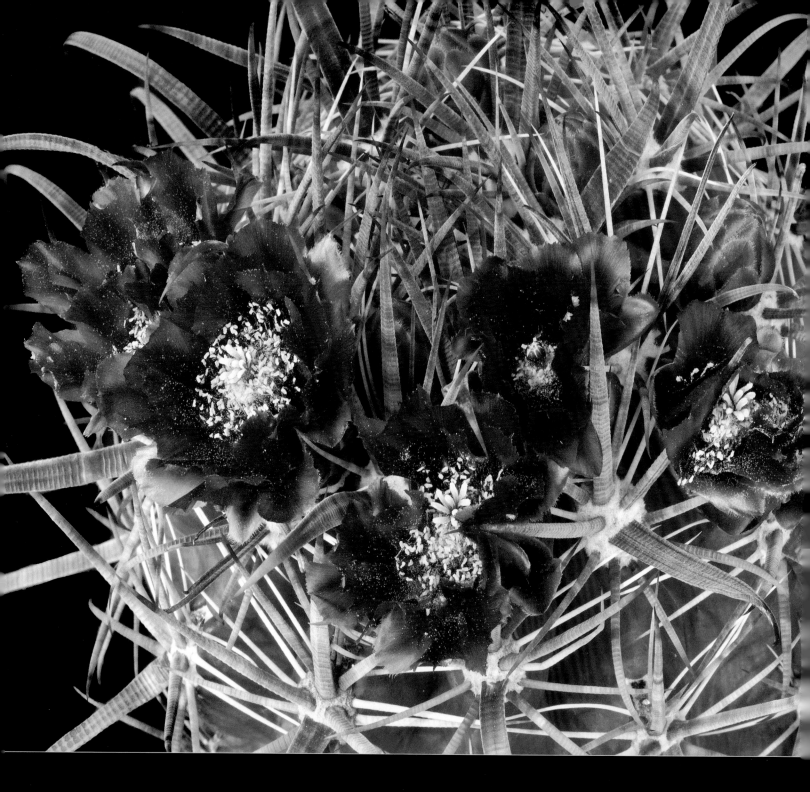

96 *Ferocactus fordii* BIZNAGA

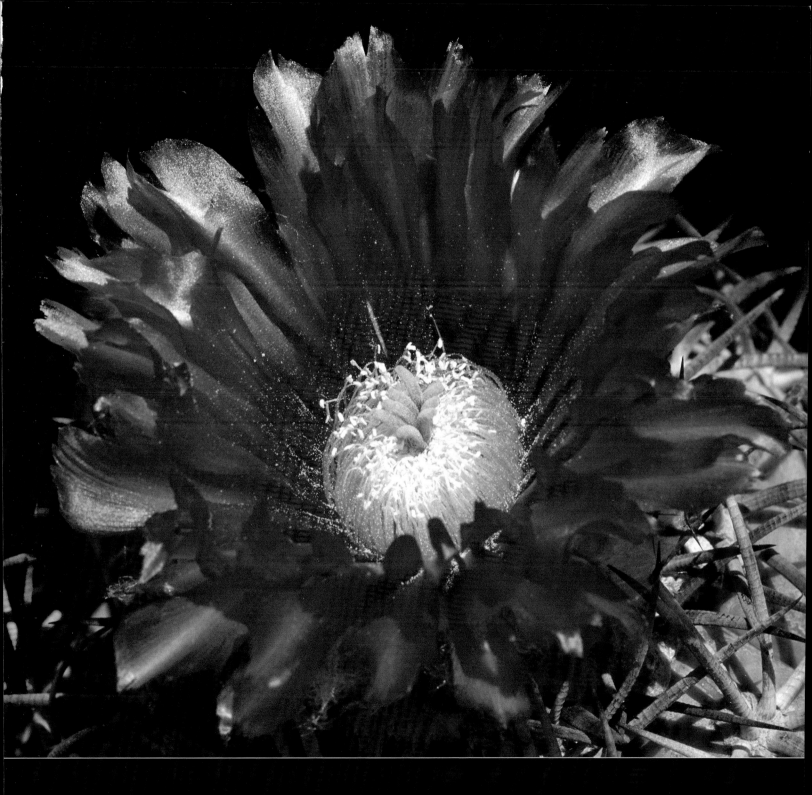

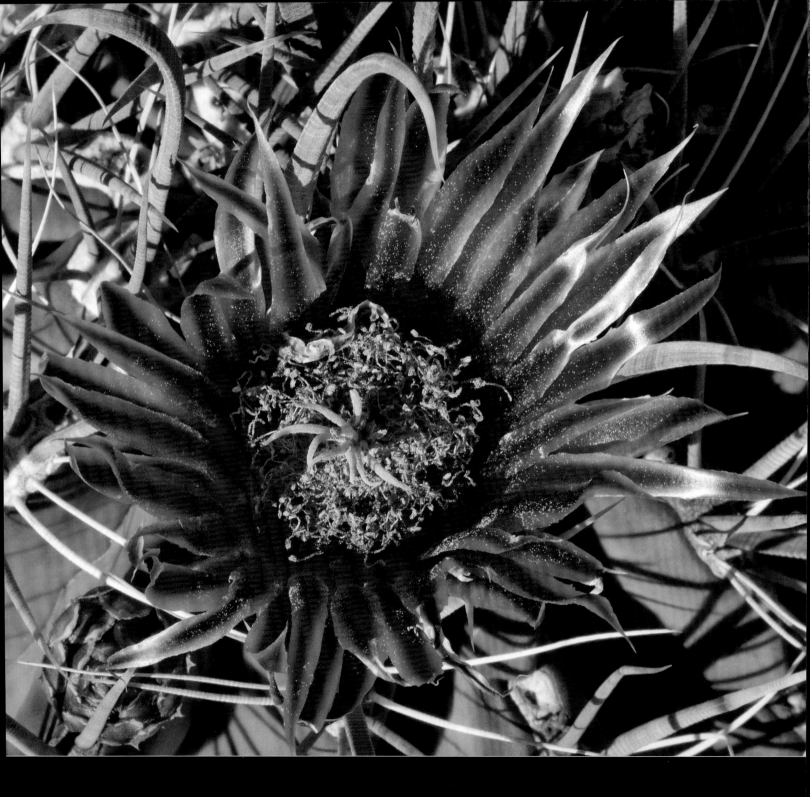

PENINSULAR BARREL CACTUS *Ferocactus peninsulae* BIZNAGA

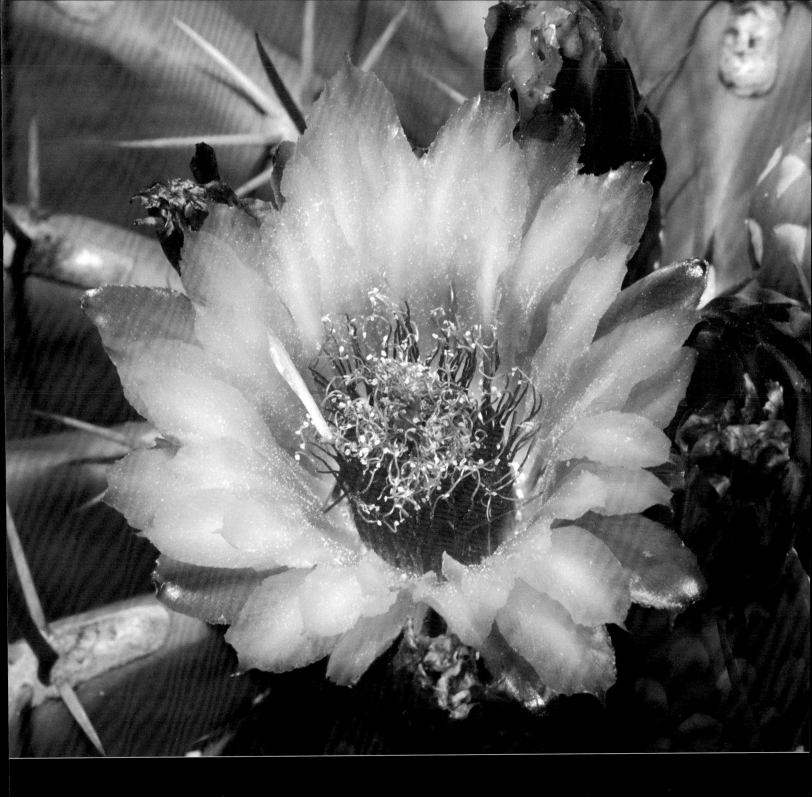

Ferocactus pottsii BIZNAGA

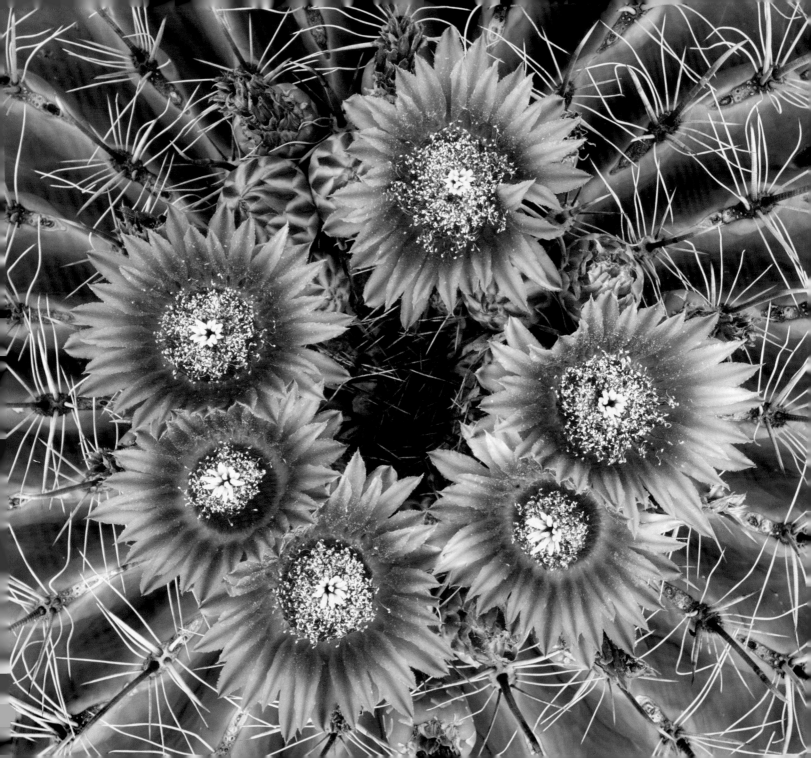

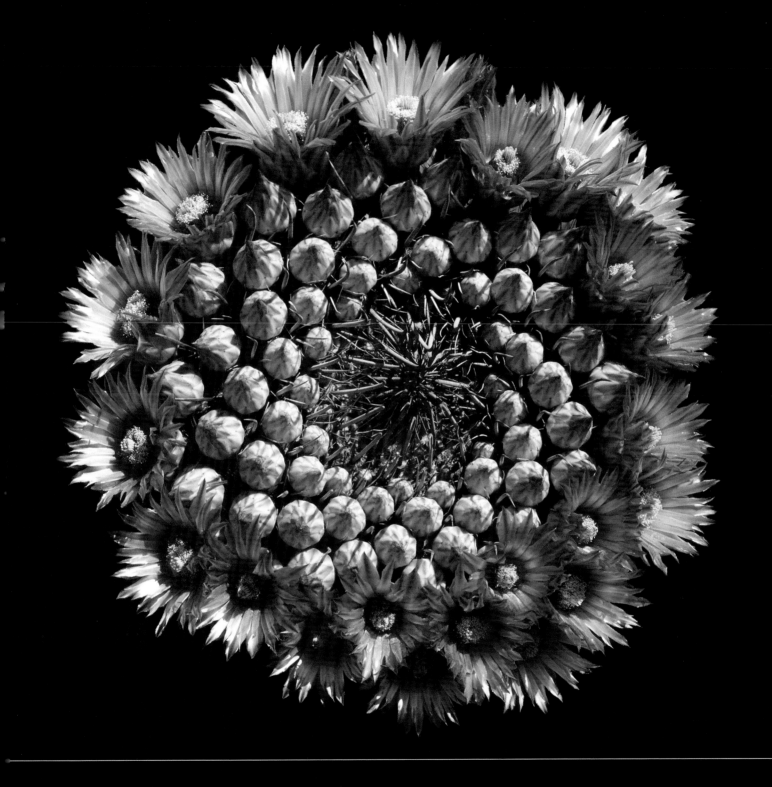

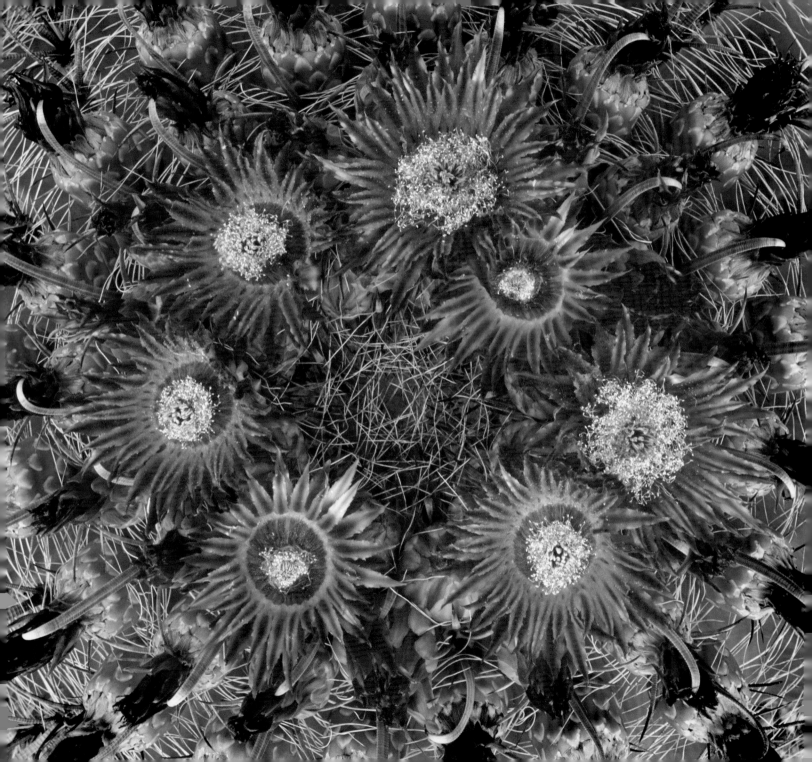

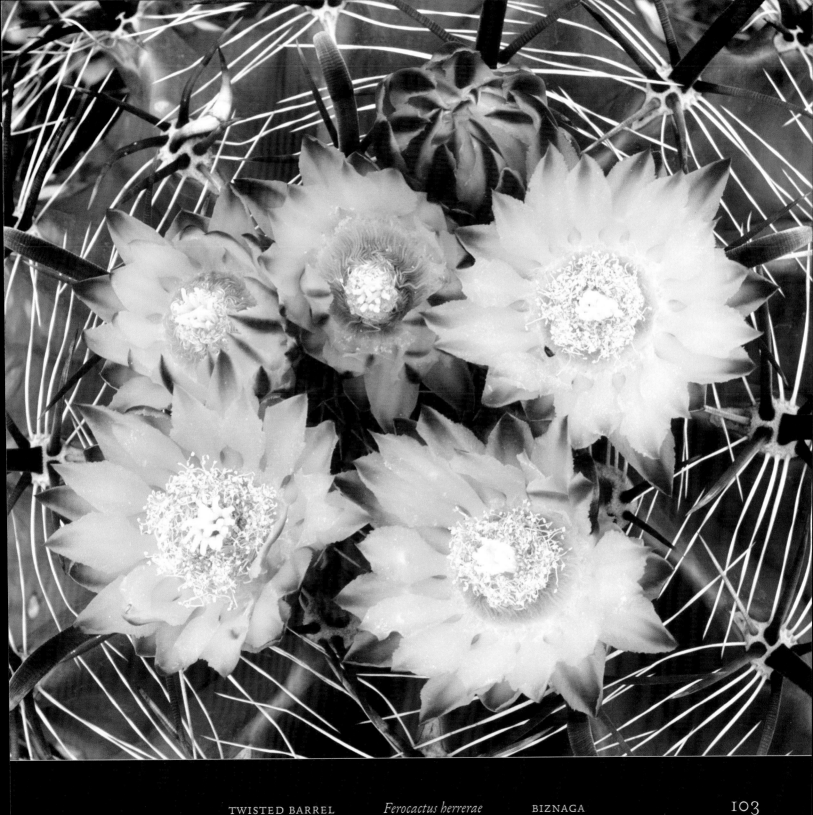

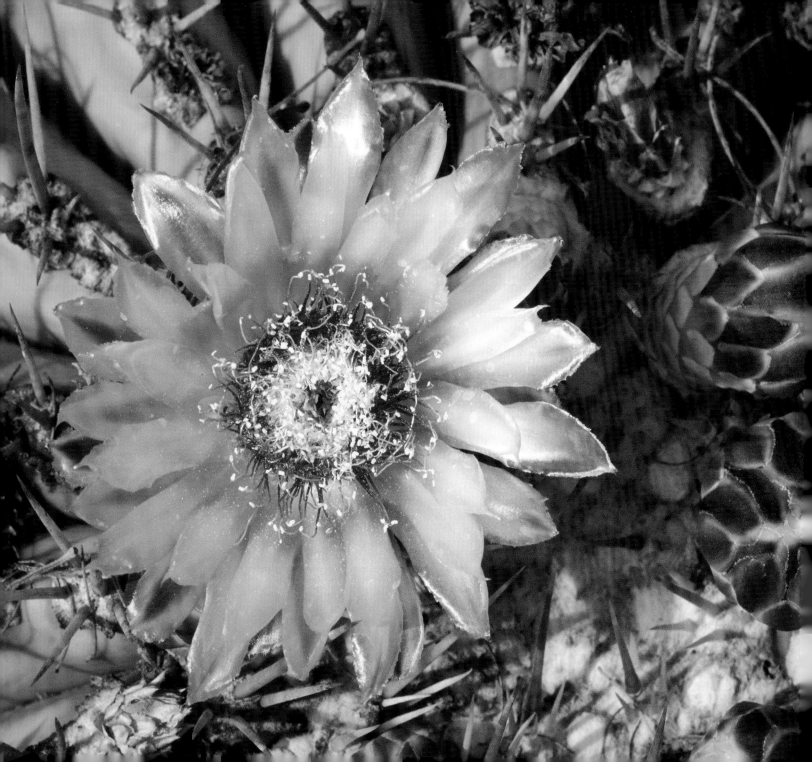

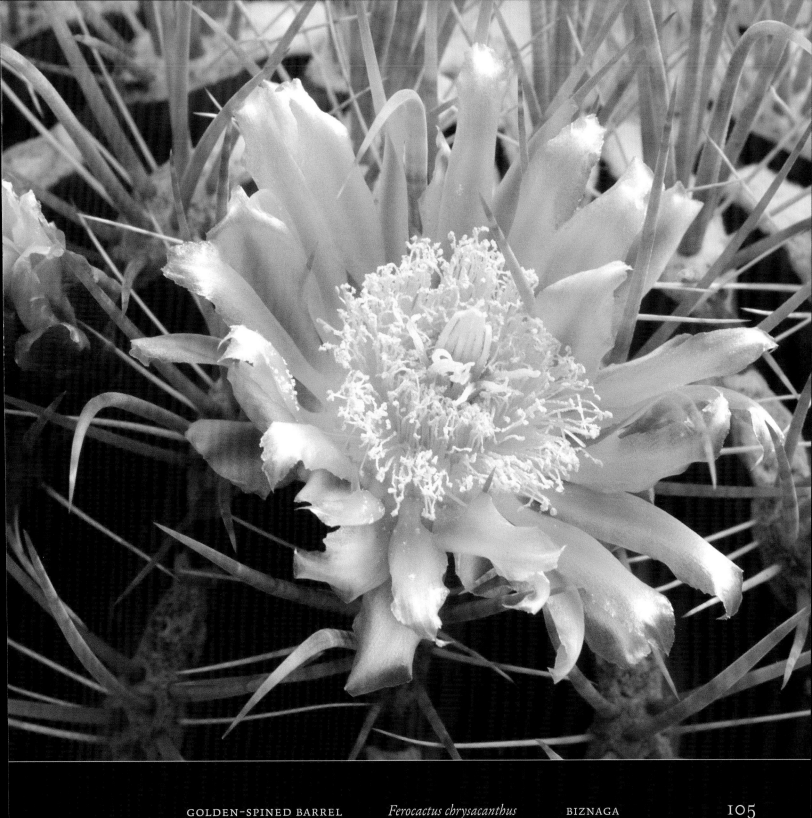

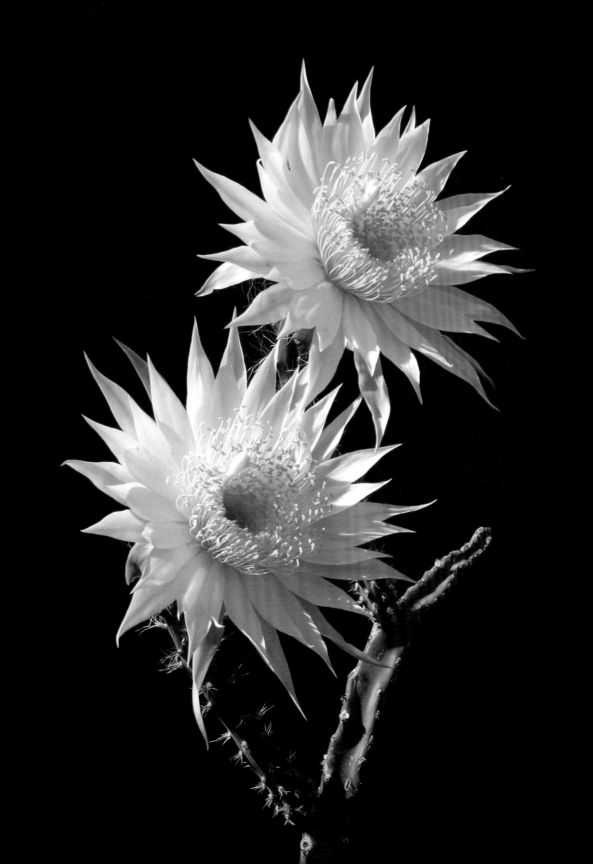

Peniocereus, UNIQUE CACTI

MARK A. DIMMITT

The genus *Peniocereus* doesn't fit into any of the other cactus groups covered in this book. Its few species have long, thin stems, tuberous roots, and nocturnal moth-pollinated flowers. The flowers of *Peniocereus greggii*, the night-blooming cereus, or Arizona queen of the night, are so rarely seen and so spectacular that their location and predicted blooming date take on almost legendary qualities in the Southwest. (Note that both of the dual English/Spanish common names for this cactus are provided on the following pages.) *Peniocereus* plants are disappearing throughout their range, due to (often illegal) over-collecting by private and commercial collectors who have eliminated entire populations from their natural habitats. Agricultural uses of land, and "development," have had large impacts on populations as well. Ironically, most species are easily propagated by short stem cuttings and from seed—there is no need for wild plants to be dug up.

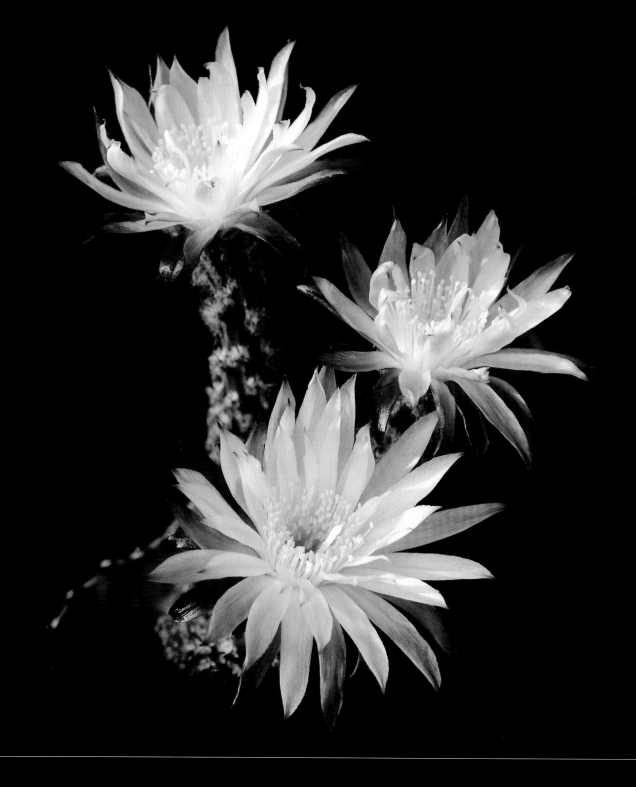

NIGHT-BLOOMING CEREUS *Peniocereus marianus* SARRAMATRACA

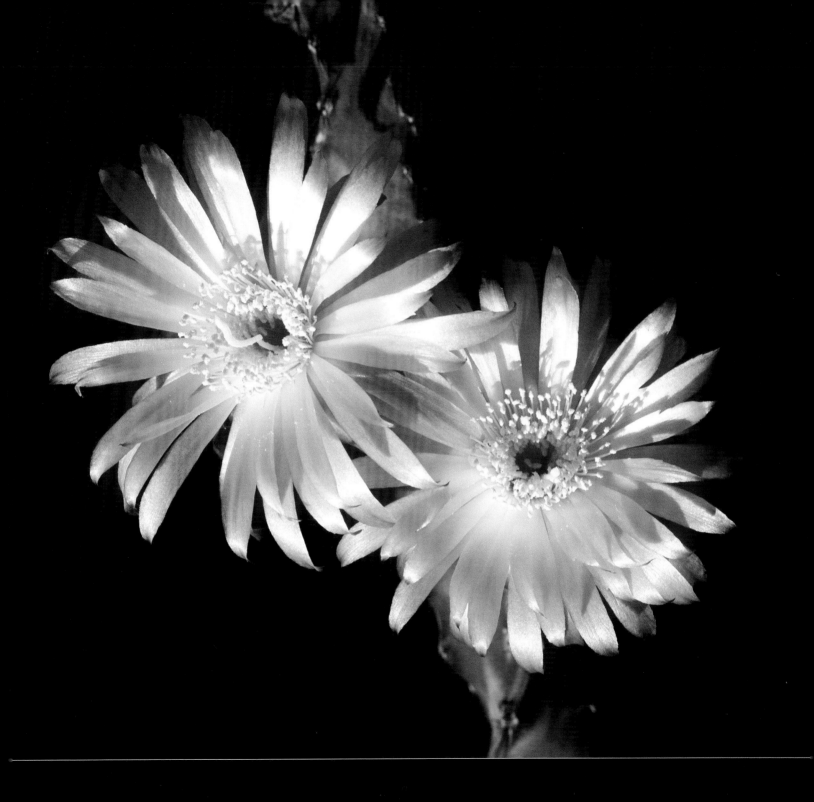

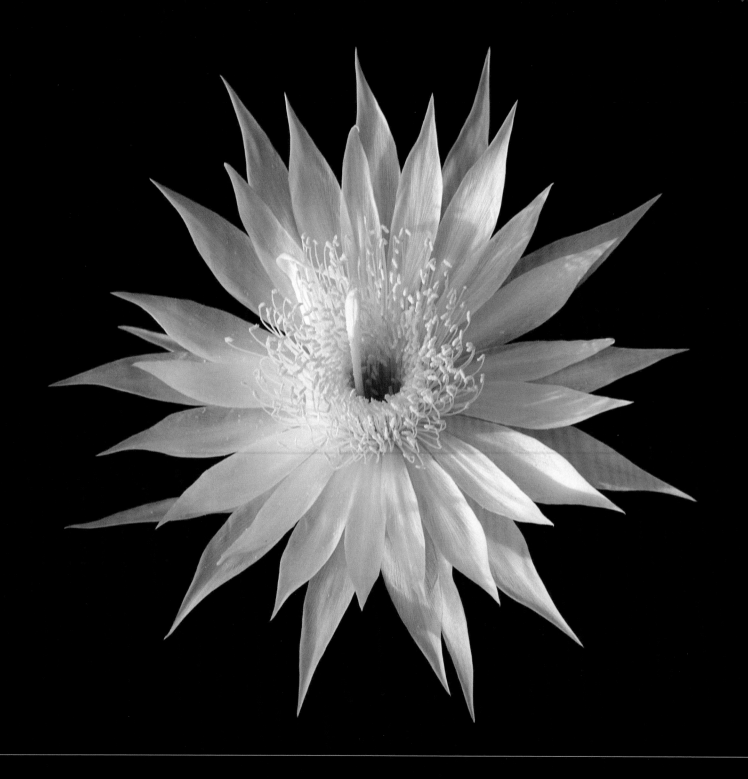

DESERT NIGHT-BLOOMING CEREUS *Peniocereus greggii* SARRAMATRACA

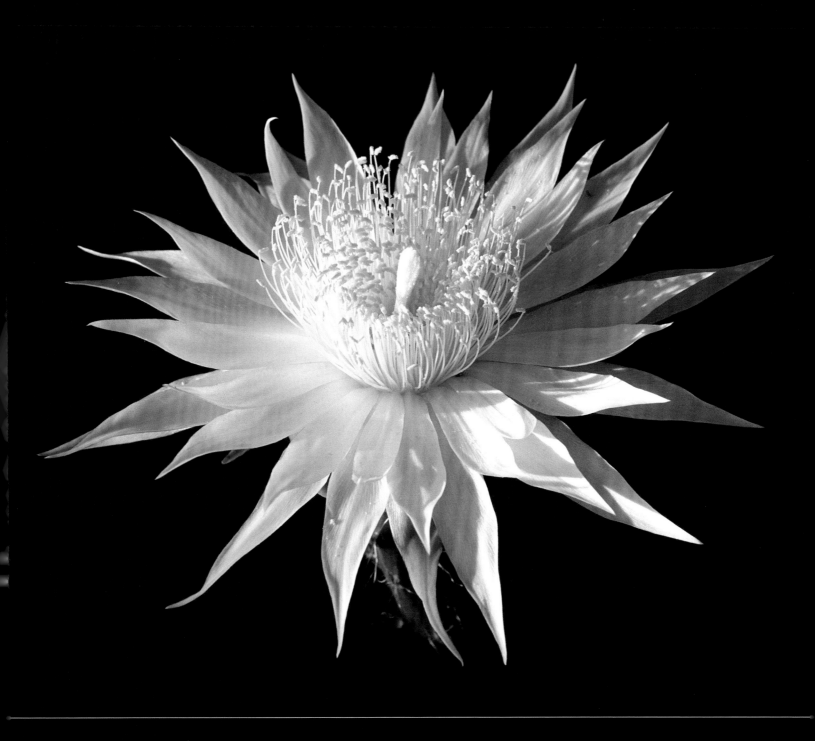

ARIZONA QUEEN OF THE NIGHT *Peniocereus greggii* REINA DE LA NOCHE III

ACKNOWLEDGEMENTS

This book would not have been possible without the help of numerous people. First and foremost is Patty Hermann who guided me to interesting plants and flowers for a good many years. Special thanks also go to Jason Rochester for his assistance in identifying and naming countless species of cacti and succulents and to Mark and Margaret Sitter for their gracious, unending hospitality at the B&B Cactus Farm. I am also grateful to George Montgomery of the Desert Museum for his help in finding some more elusive plants for me to pursue and photograph.

JOHN P. SCHAEFER